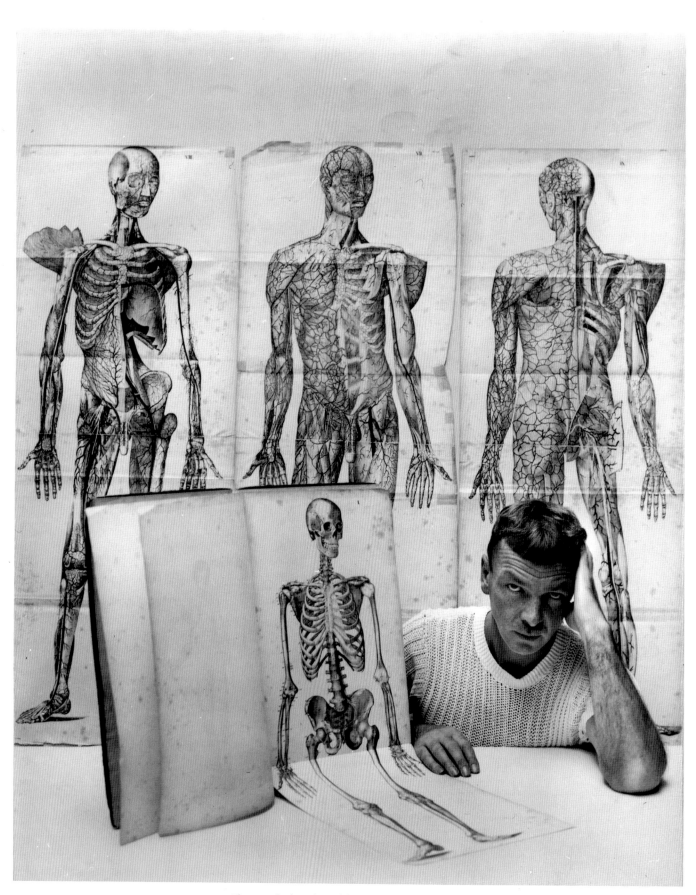

Photograph of Jared French by George Platt Lynes, 1945

A CHAMELEON BOOK

JARED FRENCH'S MYTHS

Nancy Grimes

POMEGRANATE ARTBOOKS, SAN FRANCISCO, CALIFORNIA

A CHAMELEON BOOK

Complete © 1993 Chameleon Books, Inc.
Text © 1993 Nancy Grimes
Illustrations © 1993 Estate of Jared French

Published by Pomegranate Artbooks
Box 6099, Rohnert Park, California 94927

Produced by Chameleon Books, Inc.
211 West 20th Street, New York, NY 10011

Creative director: Arnold Skolnick
Managing editor: Carl Sesar
Editorial assistant: Lynn Schumann
Composition: Larry Lorber, Ultracomp
Printer: Oceanic Graphic Printing, Hong Kong

Library of Congress Catalog Card Number 93-83936
ISBN 1-56640-322-7

First edition

FOR CYNTHIA

ACKNOWLEDGMENTS

This book would not have been possible without Bridget Moore, Director of Midtown Payson Galleries, who invited us to undertake the project, saw us through it, and introduced us to Nancy Grimes. Special thanks also to the staff of Midtown Payson Galleries, and especially to Edward De Luca, Associate Director, who went beyond the call of duty to gather the material for this book.

We thank Mark Cole, author of a doctoral dissertation for the University of Delaware examining the art and lives of Paul Cadmus and Jared French, who put together the Chronology and Exhibition History that appears in the back of the book.

Our thanks to all the private collectors who allowed their rare paintings to be shared, and to Anita Duquette from the Whitney Museum of American Art, who as always has been most accommodating and helpful.

We wish to thank Paul Cadmus, who gave his valuable time sharing his reminiscences about Jared French with Nancy Grimes, and to William Grimes, who edited the manuscript.

Special thanks are of course due to author Nancy Grimes, who undertook a difficult project in writing about a painter for whom there is little objective information available and whose works are clouded in mystery.

We are grateful to Lincoln Kirstein for allowing us use of his painting *The Double* on the jacket and for his best wishes regarding this publication.

ARNOLD SKOLNICK

Mysteries

Under close inspection and pummeled by the queries and explicit questions with which the awakened mind is completely armed, you see myths die.

Paul Valéry, "On Myths and Mythology"

A myth gets its animation from a mystery.

Edgar Wind, *Pagan Mysteries in the Renaissance*

FEW ARTISTS have done more to cover their artistic tracks than Jared French, or left fewer clues to the meaning of their work. The remarkable, startlingly original series of paintings he executed during the 1940s—uncanny tableaux of numinous, statue-like human figures—seem at once impenetrable and tantalizingly allusive. Allegorical in aspect, these paintings, which constitute the bulk of his major works, suggest a hidden text. Yet efforts to decode his images, to track down their stylistic and symbolic references, only reinforce their opaqueness. Far from being the simple allegories of the kind in which each pictorial element stands for an abstract idea, French's complex, precisely honed images evoke constellations of ideas that enrich, rather than explain the artwork, causing it to resonate more profoundly.

Like a stone thrown into still water, each picture generates a widening circle of associations that begin with French himself—his life—and radiate into the worlds of sociological, psychological and philosophical thought. Yet despite French's ability to tease the intellect into patterns of speculative interpretation, the real power of his images lies in their mysteriousness, which, like a dream or a symbolist poem, casts a spell over the imagination.

In its dreamlike strangeness, French's work invites comparison with surrealism. But the comparison is misleading. Although French could not have developed his mature work without the example of surrealism and the psychological theories that supported it, his studied neoclassicism has little in common with the automatism of artists like Miró and Masson. Nor do his allegorical tableaux resemble the hallucinatory landscapes of Yves Tanguy or the decaying neoplasmic forms of Salvador Dalí. These artists all equate the processes of the unconscious with those of organic life; they model their visual language on the protean universe of microscopic nature. French's clear, precisely calibrated forms and compositions could not be further removed from surrealist flux. For him, even the nonrational mind, or dream state, displays an architectonic order and tends toward geometric rather than biomorphic structure. Even in his late works, which are dominated by biomorphic form, biomorphism represents only one stratum of the multilayered unconscious, not its totality.

French has also been called a magic realist. This vague catch-all term is generally applied to any representational artist who eludes traditional stylistic classifications. Yet while his inexplicable images do seem magical, their extreme artificiality places them outside the realist tradition. For magic realism to serve as a useful critical category, it must be limited to those works that are both magical and realistic; that is, to works that imbue everyday reality with a supernatural or ritualistic aura. In this restricted sense, magic realism presents the world through a veil of apprehension, anxiety, or awe—the moods evoked by ritual as it summons forth supernatural forces. Artists like Edward Hopper, Grant Wood, Otto Dix, Christian Schad, and Carlo Carrà could all

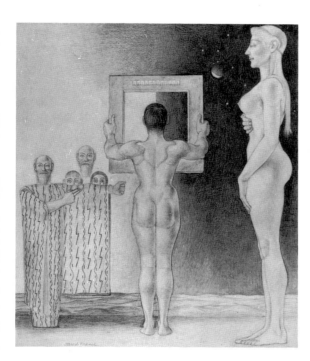

EXAMINATION AND INTERPRETATION, 1943
Pencil on paper
10¼ x 9⅛ inches
Private collection

be legitimately classified as magic realists. Unlike these artists, French does not present an extraordinary vision of an ordinary world. Instead, he ambitiously creates a new, mythic realm, one that, like Olympus, is separate from, yet linked to, the mundane order.

If he is not a magic realist, French does belong to the international movement of artists who, between the wars, revived classical forms in their seach for an ideal, essential reality. Along with painters like Giorgio de Chirico, Carlo Carrà, Massimo Campigli, and even Picasso, he borrowed stylistic features from the art of the Italian Quattrocento, the Etruscans and ancient Egypt. But again, although French carried into the 1940s an interest in classicism, his art had none of the melancholy nostalgia of the Italians, nor was his motivation, like Picasso's, primarily formal.

Thus, French's art, although related to surrealism, magic realism, and *pittura metafisica,* cannot comfortably be placed in any of these groups. In certain respects his restructuring of reality puts him in the company of the Belgian symbolists René Magritte and Paul Delvaux, artists who also reconfigure the boundaries between objective and subjective reality. Like them, he conjures up a still, portentous world in which oddly juxtaposed objects and figures, immaculately rendered to seem more real than real, throw up a challenge to rationalism and empiricism. In the tradition of symbolism, French not only suggests other realities not amenable to scientific explanation, he attempts to articulate or image those realities.

But French is a distinctly American symbolist. In style and sensibility, his strongest ties are to Paul Cadmus and George Tooker, two fellow Americans who, like French, attended the Art Students League in New York at a time when the emphasis was on craftsmanly figure painting and the documentation of urban and rural life in America. French, Cadmus, and Tooker form a distinct subgroup of the international figurative movement. Linked by their roots in American scene painting, a reverence for Renaissance art, the egg tempera technique, and above all a commitment to the human figure, these three artists, all of them homosexual or, in French's case, bisexual, shared similar aesthetic goals and values. Each placed the human figure at the center of his work and, from that vantage, sought points of convergence between contemporary experience and myth—between the transitory and the eternal.

French, the purist of the group, eventually turned his back on the social milieu in order to explore more deeply what he called "man's inner reality." To do this, he fashioned an idiosyncratic visual language drawn from the Renaissance and ancient art and based on the figures and symbols of religious myth. His images of the nonrational or spiritual aspects of the human psyche strive for classical harmony and dignity while insisting that human beings are still, even in the dehumanized twentieth century, the measure of all things.

French's output was small. He wrote almost nothing about his work, rarely spoke about it even to friends, and did very little to promote it. Even today, he is known only to a handful of specialists. Yet, for those who trouble to seek him out, to undertake the contemplative exercise his work demands, he appears as a highly original and even wise artist—one whose radical classicism forms a bridge between the present and the past, the conscious and the unconscious, the self and the world.

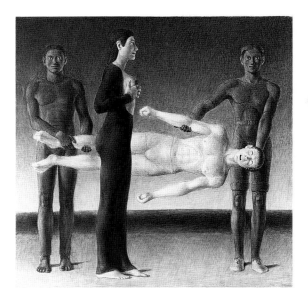

THE STRANGE MAN, n. d.
Egg tempera on gesso panel
Collection unknown

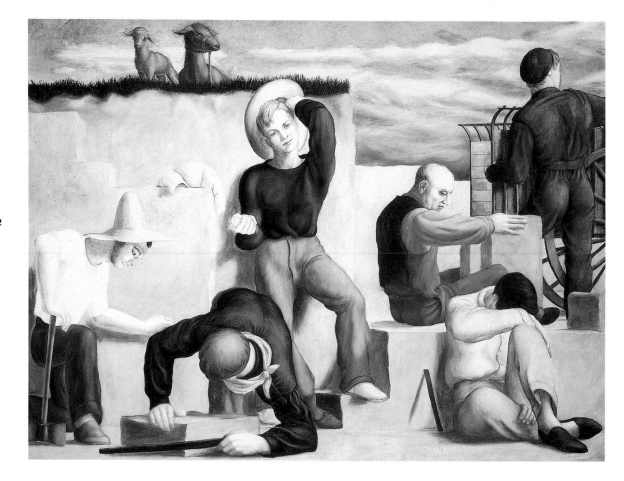

MALLORCAN QUARRY, 1932
Oil on canvas
29 x 40 inches
The Regis Collection, Inc.

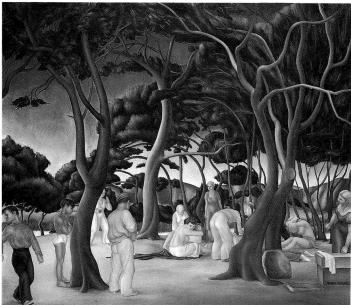

PICNIC, c. 1933
Oil on canvas
22 x 36 inches
Private collection

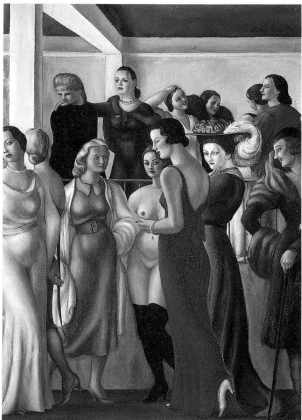

THIRTEEN WOMEN, c. 1933
Oil on canvas
21½ x 15¾ inches
Private collection

Beginnings

I can't remember when I haven't drawn and painted.

Jared French, 1943

JARED FRENCH's life is nearly as obscure as his paintings. Two of the people closest to him, his wife Margaret and Paul Cadmus, share a reticence that was also natural to French. Public records establish a rough biographical outline, but no diaries, letters or memoirs by intimate friends have emerged to fill in the gaps.

Born in 1905, French grew up in a solidly middle-class home in eastern New Jersey. His father was a roofing contractor; his mother, an amateur artist. Although his mother discouraged his interest in art as a profession (Cadmus remembers that she was protective of her turf), French nevertheless studied literature, music and visual art at Amherst College. There, from 1921 to 1925, he studied poetry with Robert Frost and worked as an assistant editor on the *Amherst Olio*.

After receiving his bachelor of arts degree in 1925, French moved to New York City and took a job on Wall Street as a clerk. He also attended classes part-time at the Art Students League, where he studied with Boardman Robinson, Kimon Nicolaides, Allen Lewis and Charles Locke, teachers whose commitment to life drawing and the depiction of everyday events profoundly affected his early work. After the stock market crash, he left Wall Street to enroll full-time at the League. There he met Paul Cadmus, who became his lover and lifelong friend.

French served Cadmus as mentor and muse. He persuaded him to give up commercial art for serious painting, and frequently modeled for him. Cadmus's portrait *Jerry,* from 1931, depicts French as a handsome, muscular young man lying seductively in bed, his upper torso bare, an open volume of Joyce's *Ulysses* resting against his side. Cadmus's French is desirable and dreamy, an attractive mix of virility, imagination and intellect.

In 1931, French and Cadmus traveled together to Europe, where they sought out the work of old masters like Piero della Francesca, Mantegna and Rubens. After touring France and Spain by bicycle, the two friends settled in Puerto de Andraitx, a fishing village on the Spanish island of Mallorca. Far removed from the getting and spending of New York, they lived and painted in relative ease until 1933, when lack of money and the expiration of their passports forced them to return to America.

On Mallorca, French applied the formulas of American scene painting to the local people and landscape. His *Mallorcan Quarry* (1932), an oil painting, sympathetically portrays the hard lot of Spanish stonecutters. Equal parts social critique and pastorale, the quarry scene conveys the spiritual oppressiveness of manual labor. From the bottom of a pit, a handsome workman looks forlornly at the viewer. On the top edge of the quarry stand two donkeys, spatially and metaphorically in a superior position to the quarrymen toiling below. Despite their oppressed state, the men are physically vigorous and well-muscled, objects of desire as well as pity.

On returning to New York, French signed up with the Mural and Easel Painting section of the Public Works of Art Project (PWAP), a New Deal program for visual artists. The following year he painted a mural for a Brooklyn high school, *A Page from American Life,* and in 1935 began a series of WPA murals. That same year, French and Cadmus rented a studio in Greenwich Village, and French began to exhibit his

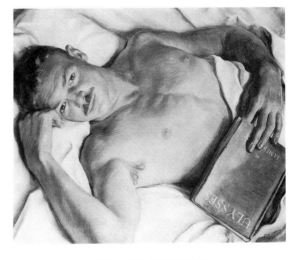

JERRY, 1931, by Paul Cadmus
Oil on canvas
20 x 24 inches
Private collection

work extensively, appearing in a total of seven group shows that season. During the next three years, French exhibited in numerous group exhibitions, including two of the Whitney Museum's Biennials and three of its Annuals. He was also given his first one-person exhibition, in 1935, at the Julien Levy Gallery in New York, which showed his now completed WPA murals, *The Origins of Food* and *Cavalrymen Crossing a River.*

French spent the 1930s trying to find his artistic voice. He continued to paint the human figure, and to develop his interest in athleticism and physical mass, already apparent in *Mallorcan Quarry,* but in both style and specific subject matter the paintings from this period seem to grope for a direction. Although most of these early works deal with contemporary subjects, stylistically they vacillate between sharp, metallic, rather static forms reminiscent of the Neue Sachlichkeit, and softer, more open, livelier ones patterned after Reginald Marsh.

In 1937, French married Margaret Hoening, also an artist. For the next eight years the Frenches and Cadmus summered together on Fire Island, where they formed a photographic collective they called PAJAMA, an acronym taken from the first two letters of the names Paul, Jared, and Margaret. At the time, Fire Island was relatively unspoiled. Not easily accessible, it offered few amenities and was only sparsely populated, even in summer. On an isolated beach near the town of Saltaire, French found vestiges of a primal landscape. As the Atlantic rhythmically pounded the shoreline and sea winds weathered the forms of nature and man into primordial dust, he and his friends assumed stilted poses for the camera. Sometimes the three were joined by associates such as Lincoln Kirstein, George Tooker, Cadmus's sister Fidelma, the Wisconsin writer Glenway Wescott, the photographer George Platt Lynes, and Monroe Wheeler, head of exhibitions at the Museum of Modern Art.

Many of French's photographs show figures—usually Margaret alone (often draped in a blanket) or Margaret and Paul—standing or reclining on the empty beach like outcroppings of the land itself. In one photograph, from 1939, three figures are arranged to conform to the horizontal and vertical bars of a jungle gym, like living components of an ur-architecture. Merging the human body with the forms of nature and architecture, the PAJAMA pictures describe a remote, timeless world that serves as a model and inspiration for French's paintings from this period.

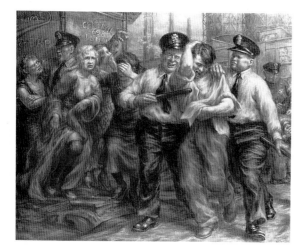

THE RAID, 1936
Oil on linen mounted to panel
32½ x 39½ inches
Private collection

RICHMOND, VIRGINIA POST OFFICE MURAL, c. 1938
Oil and tempera on canvas
Size and location unknown

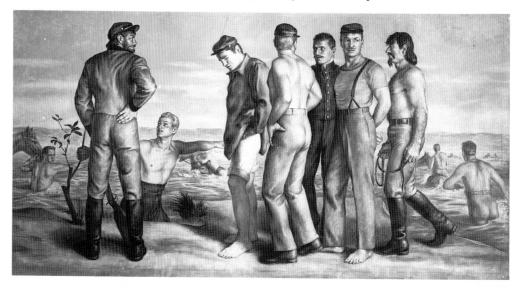

Classicism

The possession of originality cannot make an artist unconventional; it drives him further into convention, obeying the law of the art itself, which seeks constantly to reshape itself from its own depth.

Northrop Frye, *Anatomy of Criticism*

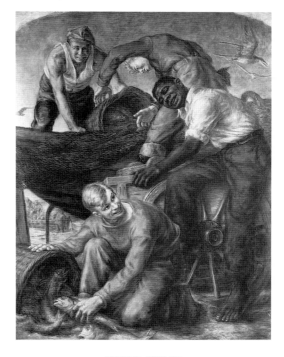

I N FRENCH's WPA murals, Glenway Wescott saw the embryo of the painter's mature work. His catalogue essay for the Julien Levy exhibition applauded French's conceptual and technical progress, noting that "when his mind was made up—that is, when a peculiar vision of what to paint appeared to him and was accepted by him proudly—then there occurred a sudden acceleration of technique, elimination of influences, focussing of cross purposes; a blooming of the palette, and dancing of the hand and brush." According to Wescott, French's artistic coming of age was distinguished by "the sudden appearance of his characteristic monumental form and roomy kind of composition and gloomily vivid colors."

Wescott's description anticipates the dramatic change of direction the artist's work would take in 1940. That year, French switched painting mediums, exchanging oil for egg tempera—a venerable technique known to Giotto and, probably, to the ancient Greeks. Paradoxically, the slow, finicky process of tempera painting liberated French's imagination. All of his major works from 1940 on were painted in egg tempera on wooden panel or composition board. The smooth matte surface of tempera and the dusty luminosity of its pigments suited French's vision of a remote, seamless reality. Egg tempera helped him create an even, opalescent light that softened his ponderous, chiseled forms without sacrificing their clarity; it imparted to the skin of his figures a flawless, buffed quality that made them seem as though they were made from a dense, synthetic material combining the characteristics of flesh and marble.

French borrowed more than egg tempera from the Italian Renaissance. Wescott had already identified the monumental forms of the WPA murals as "characteristic" of the mature French, but his monumentality found its clearest, most refined expression in the figure type he developed in the early 1940s. At that time, French's "roomy space" stretched into stark, empty strands reminiscent of the lonely beach at Fire Island, and the ponderously muscled figures of the murals assumed the classical proportions and dignified bearing of Renaissance models.

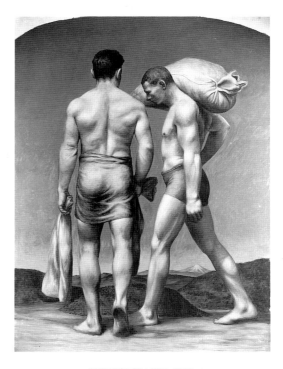

One of French's favorite texts was *On Painting,* by the great humanist Leon Battista Alberti, which deals, in part, with the proper composition of human figures. "In the composition of members," he wrote, "care should be taken above all that all the members accord well with one another....The architect Vitruvius reckons the height of a man in feet. I think it more suitable if the rest of the limbs are related to the size of the head...having selected this one member, the rest should be accommodated to it, so that there is no member of the whole body that does not correspond with the others in length and breadth."[1]

This interest in harmonious proportion, common to the Renaissance as a whole, went far beyond mere allegiance to perceptual verisimilitude. The Italians invested the ancient theories of proportion that they inherited from the Greeks with a new significance. For Renaissance artists, formulas for human proportion were not only useful, they also reflected the order of the cosmos and, because they were

mathematically derived, formed the rational basis for beauty. Harmonious proportion was of the highest philosophic import because it aligned the microcosm (man) with the macrocosm (God).[2]

It is difficult to determine whether French directly applied traditional formulas for proportion, which in any case tended to be vague and contradictory. But his figures do reflect the harmony characteristic of such formulas and display a consistent, mathematically analyzable pattern of relationships. Three egg tempera portraits from 1940 to 1942 demonstrate a system of proportion that French used often. These paintings present their male subjects—George Platt Lynes, Glenway Wescott and **19, 18** Monroe Wheeler—full-length and nude, standing in a shallow space with feet splayed **20** and arms dangling passively at their sides. Each figure is roughly eight heads tall—the bottom edge of the pectorals falls two head-lengths from the figure's crown, marking one-quarter of its entire length; the navel appears three head-lengths from its crown; another head-length separates the navel from the groin, which locates the figures' central horizontal axis, cutting it in half; the bottom of the kneecap quarters the figure again at six head-lengths; and so on.

French's balanced, static system of proportions imbues his figures with a godlike quality that is reinforced by their frontal, immobile poses. In his essay "Stereotyping of Art," Arnold Hauser writes: "Ancient-Oriental art...makes a direct approach to the receptive subject; it is an art which both demands and shows public respect. Its approach to the beholder is an act of reverence, of courtesy and etiquette. All courtly and courteous art, intent on bestowing fame and praise, contains an element of frontality..."[3] Thus, French uses the devices of both Renaissance and ancient art to transform his friends into princely beings who stand, divinely naked, on the threshold of myth.

French crosses that threshold in *Washing the White Blood from Daniel Boone,* **2** also painted in 1939. Here, he conflates an episode from American legend with *The Baptism of Christ* by Piero della Francesca, a courtly painter himself. French's weird fusion of the American scene with religious myth might, at first glance, look like an exalted version of the heroic history painting of the WPA murals. But, seen in the context of French's life and subsequent artistic development, the work takes on other meanings. The painting, which depicts the initiation of a white man into a band of "primitive" men, accords heroic status to sexuality (here represented by the supposedly more potent dark-skinned races), and specifically to homosexuality (note Daniel Boone's obtrusively feminine underpants). It also suggests, by alluding to the sacrament of baptism, a kind of spiritual rebirth. French chooses Boone as his central figure because he was an explorer of a mysterious, alien territory populated by aboriginals who participate in mythic rather than historical time. Shed of his ties to the "white" world of history, and purified by religious rite, Boone prepares to enter the underworld of the unconscious—the dark repository of myth.

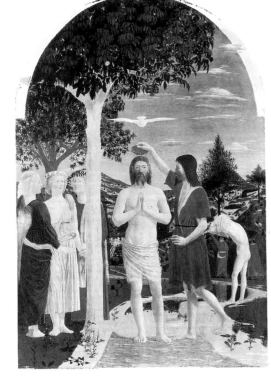

THE BAPTISM OF CHRIST by Piero della Francesca
London, National Gallery

The Double

Ille. *By the help of an image*
I call to my own opposite, summon all
That I have handled least, least looked upon.

Hic. *And I would find myself and not an image.*
<div align="right">William Butler Yeats, "Ego Dominus Tuus"</div>

But I, Narcissus, who am cherished, only this,
My solitary essence interests me.
<div align="right">Paul Valéry, "Narcissus"</div>

N 1968, French published a rare, terse statement about his work in *Art International.* "My work has long been concerned with the representation of diverse aspects of man and his universe," he wrote. "At first it was mainly concerned with his physical aspect and his physical universe. Gradually I began to represent aspects of his psyche."[4] While his early work celebrates the physical, sexual body (and finds a literary parallel in the novels of D. H. Lawrence, a major influence), French, from 1940 on, trades an objective vision for a subjective one, turning away from the physical world in order to delve deeply into the nature of psyche and self. Several works from 1940 announce French's transformation from a realist to a symbolist and, like *Washing the White Blood from Daniel Boone,* take the idea of transition, or spiritual passage, as their theme.

26 *The Double,* an egg tempera painting, uses a resurrection scenario to masterfully restate French's preoccupation with heroic physicality. Now, however, the beautiful, gracefully proportioned body becomes not just a reflection of spiritual harmony but a symbol for the psyche, or self, in general. In this painting, four figures—a matron and three young men—stake out positions across a barren field or strand whose bleakness is intensified by smokestacks rising in the distance. The narrative is ambiguous. The central figure, a handsome, pallid youth, completely naked, is either about to rise from or sink into a shallow grave. He is watched by his double, a rather fussily dressed figure in turtleneck and hat, who kneels with his thighs pressed tightly together and one palm upturned, as though urging his twin to rise. Sitting on a fence at a slightly higher level (here again, French uses different physical levels or heights to indicate varying states of spiritual growth), a young black man, half-dressed, relaxed and uninhibited, sits with hands cupped between open thighs. Behind this group, to the left, lurks a funereal specter, a woman in a dark Victorian dress and a phallically feathered hat. This ominous figure, compositionally linked to the pillars of industry on the horizon, stands ready to place a blood-red leather wreath on the grave, but, smaller and placed at a distance from the others, she seems to belong to the past.

Certainly the painting alludes to the conflict between Victorian values, in retreat yet still influential, and a younger, more open generation. But the three young men also represent varying states of spiritual and sexual freedom, with the unclothed youth, monumental and erect, representing the naked or unrepressed self arrested midway in its upward passage from the unconscious to consciousness.

It was around 1940 that French began to read in depth the writings of Carl Jung, whose *Archetypes and the Collective Unconscious* had a profound impact on his work. French, already critical of American society's repressive attitude toward sensuality,

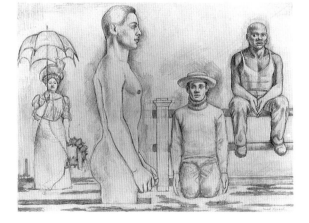

THE DOUBLE, c. 1950
Pencil on paper
11 x 15⅛ inches
Dr. and Mrs. Elton Yasuna Collection

could not help but be attracted by Jung's belief that the modern world, with its worship of science, suffers from spiritual impoverishment. Jung believed that twentieth-century man, by setting up reason as a false god, severed himself from the shadowy spirit life of the unconscious, his link to an infinitely ancient past—a past to which French had always been drawn.

French became fascinated with Jung's theory that the mind contains an inherited substratum, the collective unconscious, made up of archetypes—archaic symbols that recur in myth, dream or fantasy, and often take on a human form. According to Jung, whenever archetypal material emerges, it forces recognition from the ego, which, by making room for the previously unconscious content, creates a more balanced self. The will toward greater equalization of conscious and unconscious is part of the maturation process of human beings. Jung wrote: "When a summit of life is reached, when a bud unfolds and from the lesser a greater emerges, then, as Nietzsche says, 'One becomes Two,' and the greater figure, which one always was but which remained invisible, appears to the lesser personality with the force of a revelation. . . . [T]he man who is inwardly great will know that the long expected friend of his soul, the immortal one, has now really come. . . . Christ himself is the perfect symbol of the hidden immortal within the mortal man." [5]

In *The Double,* Jung's "greater self" rises Christ-like from a grave. In another painting, a casein also called *The Double,* the hidden self indeed appears with the force of a revelation. This work shows a nude young man, who, while looking into a hazy void, is awestruck at discovering a ghostly version of himself. Surprised and enthralled by the appearance of his unknown twin, the young man startles his shadowy reflection, which returns his look of astonishment.

In the second *Double,* French finds the perfect image for Jung's process of self-discovery, which divides the personality into two reflecting selves or subjects, each the object of the other's dawning comprehension. Jung describes this split self as a "pair of Dioscuri, one of whom is mortal and the other immortal, and who, though always together, can never be made completely one. The transformation processes strive to approximate them to one another, but our consciousness is aware of resistances, because the other person seems strange and uncanny." [6]

French elaborates this notion in *Help,* a tiny painting on ivory that depicts a pale nude man carrying his suntanned counterpart out of the sea. The pale youth, white-skinned because he dwells in the dark of the sea or the unconscious, heroically shoulders the tanned youth, darkened by the light of consciousness, carrying him safely from a near-fatal baptism to higher ground. *Help* reverses the roles of the rational and instinctual natures of human beings by casting the unconscious, the stronger of the two, as the savior of a foundering consciousness. [7]

Jung's psychological treatment of myth—his claim that it gave expression to primordial psychic content whose recognition was necessary for mental health—prompted French to explore and exploit more thoroughly the forms and themes of past art, which were often of a religious / mythical character. Jung's project of reconciling man's unconscious spiritual life with his conscious rational existence must have had an irresistible appeal to French, who, like D. H. Lawrence, was deeply concerned with

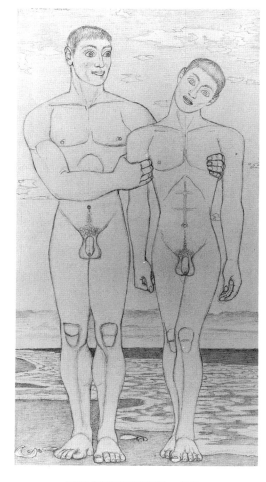

TWO STANDING NUDES, c. 1945
Pencil on paper
8⅞ x 4⅞ inches
John M. Thayer

27

the schism between modern life and the instinctual roots of human nature.

With its blend of science and myth, Jung's thought also enabled French to give free rein to his symbolist impulses by providing him with a bridge from the body to the mind. Although French shares with the symbolist poets of the early twentieth-century a fascination with self-reflection, his was a fleshly symbolism, rooted in the body. Jung permitted French to move into the subjective territory of the self without abandoning the physical and social worlds. By positing a material connection between physiology, instinct and the imagination, Jung allowed French, a social critic with a reverence for physical power and prowess, to probe without guilt the deep layers of the self.

Aspects of Man

Day after day I have sat in my chair turning a symbol over in my mind, exploring all its details, defining and again defining its elements, testing my convictions and those of others by its unity, attempting to substitute particulars for an abstraction like that of algebra.

William Butler Yeats, *A Vision*

JUNG's *Archetypes and the Collective Unconscious* exerted an influence on French that was matched by only one other book, William Butler Yeats's *A Vision*. Yeat's dense, nearly impenetrable theological treatise is a strenuous exercise of the imagination that attempts to illustrate and explain man's nature, his present and past lives, and, in fact, all of history through an elaborate symbolic framework based on cones, or "gyres," that oscillate between pure subjectivity and pure objectivity, states that Yeats refers to as the antithetical and primary tinctures. The system takes as its model the 28 phases of the moon, which demarcate various points along the gyring, overlapping paths of the tinctures. At certain points along the route, man is dominated by his subjective nature; at others, by objective reality.

The influence of *A Vision,* notably its ambitious scope, can be seen in an extended series of paintings and drawings from the 1940s and 1950s, in which French set out to define the whole of human nature through an elaborate allegorical system. In a set of scribbly charts he had worked on for a number of years earlier, French divided man into seven primary aspects: body, functions, work, play, "man" (a category that included language, dress, government, crime), nature, and creation. Although hierarchically numbered, the seven groups were, according to a marginal note, "not a progression, but a shifting kaleidoscope." French further divided each main category into seven subcategories, which provide the subjects or themes for paintings and drawings. In one chart, the primary group, "Functions," encompasses the subgroups "Growth and anomalies," "Breathing, sweating, stretching, running, walking," "Eating," "Defecating," "Sleeping," "Sex," and "Birth." In the same chart, "Creation" contains "Chaos," "The decorative arts," "Painting," "Prose," "Poetry," "Music," and "Sculpture."

Although French translated many of his 49 aspects into paintings, he never completed the entire series. Perhaps the sheer ambition of the scheme exhausted him, for his aspects are not simple illustrations of human activities, but highly concentrated

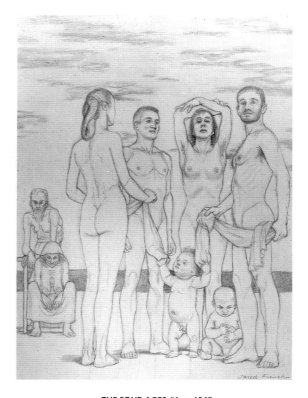

THE FOUR AGES #1, c. 1945
Pencil on paper
10³⁄₁₆ x 8⁵⁄₈ inches
Private collection

EAT, c. 1948
Pencil on paper
7½ x 11½ inches
Private collection

symbolic evocations of human essences and first instances. Thus, *Eat,* a study for the subcategory under "Functions," depicts a naked man and a woman on a beach, the man sitting, the woman squatting, as they consume the fruits of the earth and the fish of the sea with ritualistic solemnity. An American scene painter, handling the identical subject matter, might have shown a family at table enjoying the Sunday roast, the reward of hard honest labor. French, however, creates an archetypal image. His Adam and Eve seem to be eating for the very first time. Their act of consumption takes on religious overtones, as though they were guided by a spiritual as well as a physical appetite.

Here again, French is operating in the realm of Jung's collective unconscious, that stratum of the psyche that becomes manifest in myth. Clearly, in the works illustrating the aspects of man, French attempts to create a mythic world peopled by archetypal figures engaged in archetypal acts. If myth can be defined as a mode of thought by which primitive man sought to give order and meaning to the chaos of external sense impressions, then surely French is using elements drawn from myth to give structure to the chaos of twentieth-century man's inner life.

In the myths of ancient Greece and Egypt—the legacy of our remote historical past—French found images ideally suited to describe the remote regions of the psyche. He repeatedly used the conventions of ancient myth and art to fashion archetypal figures and scenes which, numinous and allusive, trigger powerful psychic responses. The stately, radiant nude in *Woman* (1947) stands with one foot slightly forward, arms held close to her sides, a mysterious half-smile on her lips—the exact posture and facial expression of a Greek kouros.[8] French seamlessly weaves, into a single composition, four different views of this athletic goddess, who, like Venus, seems to have risen from the sea behind her. With her serene bearing and magical ability to divide, French's woman suggests Jung's idea of the anima—a man's repressed feminine aspect, which often appears to consciousness "as an angel of light, a psychopomp who points the way to the highest meaning."[9] The idea of the anima as the embodiment of all that is highest in man appears also in *Painting and Sculpture* (a subdivision of Creation in French's schema), which shows a painter standing on tiptoe stretching to paint a smiling female—virtually the same figure as in *Woman*—against a background of limpid sky.

WOMAN (FOUR FIGURES)
Ink on paper
7½ x 7½ inches
Private collection

French frequently portrays his women as potent goddesses. Even the sleeping woman in *Figures on a Beach,* a 1940 painting close in spirit to the PAJAMA photographs, seems to exert a magical influence on the two young men who attend her. Her head covered by a purple hood, her pale body partially covered in a blue cloak, she seems to have come from the sea, exposed by the receding tide or perhaps fished out by the youth with the rope. Kneeling beside her, another young man solemnly covers his own nudity with a white towel, as though suddenly overcome by modesty in the woman's presence. Here, French's woman suggests both Mary, the Virgin Mother, and Artemis, the virginal goddess of the Greeks who tamed beasts and demanded chastity from her companions.

In *Shelter,* a painting from 1944 that illustrates a sub-category of "Work," French's goddess takes on yet another guise. Here, a clothed woman with the stiffened arms and staring eyes of an ancient Greek *kore,* sits enthroned on a crate while a workman fashions a tentlike structure, presumably for her protection. The ritual takes place not on a sunlit beach, but against a violet night sky illuminated by a ghostly, lunar light. The moon aligns the woman with Persephone, the queen of the Greek underworld, who, like the moon, disappears periodically. into rejuvenating darkness. In *Shelter,* French masterfully conflates the idea of shelter with withdrawal, dormancy, sleep and death.

In *The Philosophy of Symbolic Forms,* Ernst Cassirer divides mythic reality into two spheres, "the mythically significant" and "the mythically irrelevant"—the sacred and the profane.[10] French's development can be seen as a progressive trimming away of the profane in a search for the sacred. In each of the "aspects," he attempts to uncover, through a process of reduction and purification, the spiritual kernel at the heart of every human attribute and activity. For French, "man" symbolizes reality as a whole—he contains the universe, and each of his "aspects" represents the point at which distinctions between his apprehension of reality and reality itself dissolve. By transcending a false dualism, human beings once again exist in harmony with their own nature. Encyclopedic in ambition, French's 49 aspects attempts to give poetic structure to the amorphous, protean spiritual life of human beings, the life that French, the idealist, believed to be the basis or original ground of human reality.

PAJAMA PHOTO
MARGARET FRENCH AND PAUL CADMUS, FIRE ISLAND, 1941
Vintage silver print
9 x 6¼ inches
Midtown Payson Galleries

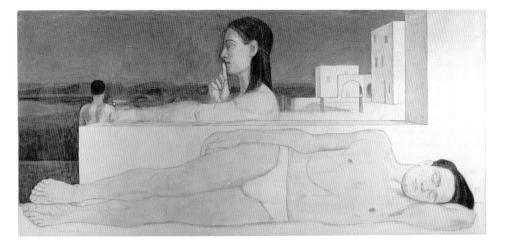

SLEEP, n. d.
Ink and inkwash on paper
13½ x 28½ inches
Private collection

Endings

It has been asserted that art at the present time has become only a marginal activity. If this is so, the artist can hardly be held to account. The artist presents. Society decides when it wants to accept; and whether it wants art near the center of its world.

Jared French, 1968

DURING THE 1960s, French changed his imagery, moving from the allegorical figuration of the preceding two decades to a kind of classical biomorphism. He dismembered his gods, as it were, and cast their bodies upon the earth, where they grew into fantastic conglomerations of flesh and land that vaguely resemble eroded sculptural monuments. Previously, French's glassy-eyed mannikins performed rituals in the service of an unseen power, whose presence was manifested in the geometric order of each picture's forms and composition. In the late works, an anthropomorphized landscape heaves with primordial energy. If the earlier works captured states of being, these final drawings and paintings image the process of becoming.

A group of pencil and ink drawings from the mid-1960s, with titles like "The Guardian," "Hero," and "Offended Gods," depict biomorphic monoliths that, at first glance, look like weird rock formations. On closer inspection, fragments of human torsos, heads, pelvises, and genitalia emerge. Human anatomy seems to be either collapsing into or emerging from some less differentiated state. The surfaces of these conglomerates are smooth and supple; their forms, solid and elastic. They appear to be in a state of metamorphosis rather than decay.

French painted only a few of these arresting images. The addition of color — French's characteristic dusty warms and cools — gives a grotesque, unearthly quality to *Nest* (1968 / 69), in which a mass of fleshy and cartilaginous forms appear to have sprung up, funguslike, atop a seaside cliff. This alien, hermaphroditic creature, made up of orifices, buttocks, faces and spines, seems to have impregnated itself and is hatching its egg on a nest of flesh, bone and cloth.

"In 1961, without conscious prevision, I began a series of sketches that led to my present work," French wrote in his artistic statement for *Art International* in 1968. "It may seem at first sight that this work marks a break with what went before. But it is in reality a development and a further clarification." French's remarks suggest that the biomorphic works were generated spontaneously, perhaps from some automatic process. Most certainly they represent his continuing exploration of Jung's collective unconscious. These works probe downward, into a deep subhuman layer of the psyche, as if seeking its very center, home of the monstrous being in *Nest* and its egg, a symbol that Jung describes as the birth site of the cosmos, of philosophy and of "the spiritual, inner and complete man."[11]

In 1969, French exhibited his biomorphic paintings and drawings at the Banfer Gallery in a kind of mini-retrospective made up of works from the mid-1940s to the late 1960s. The last of only six solo exhibitions by French in his lifetime, it met with a tepid and confused critical response. Writing in *Art News*, Rackstraw Downes, a plein-air realist, balked at the work's "artificiality" and spoke contemptuously of its "unconvincing situations with figures in stagy attitudes and time in inanely literal arrest."[12] In *Arts*, Gordon Brown, misinterpreting French's images as biomorphic ruins, called the late paintings "effective commentary on the folly of man,"[13] while

33

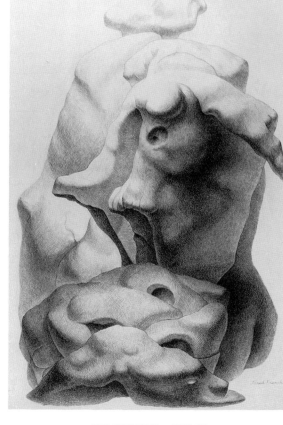

THE GUARDIAN, c. 1966–67
Pencil and ink on paper
39¼ x 25½ inches
Midtown Payson Galleries

James R. Mellow, in *Art International*, called the artist a magic realist whose "most rewarding pictures are those from the middle period in which...the themes and sentiments appear to be nostalgic for lost youth and virility."[14]

This critical floundering reflects the attitudes of an art world so steeped in formalist aesthetic theories that it had not only lost its taste for symbolic representation, but had forgotten how to interpret images. Clearly, in 1969, French had not yet found his audience. Faced with indifference or blank incomprehension in New York, he chose to withdraw and settle permanently in Rome, where he had maintained a residence since 1961. There, on January 15, 1988, he died in self-imposed exile, leaving behind a body of work that, he believed, would eventually find its rightful place in history.

In retrospect, French appears as a great symbolist, perhaps the greatest American symbolist of this century. Heedless of shifting fashion, he singlemindedly pursued his artistic program, creating, in an imaginative tour de force, a symbolic system that bears comparison, in its depth, scope and audacity, to those of Yeats and Blake. While other artists of his time were ruthlessly purging their art of content down to the husk of pure form, French endowed his curiously wrought, difficult images with an overplus of meaning. Uncanny, forbidding and aristocratic, his art demonstrates the ability of myth and symbol to lift the art work from the realm of dead objects, investing it with the inexhaustible power of enchantment.

Notes

1. Leon Battista Alberti, *On Painting* (New York: Penguin, 1991), pp. 72–73.

2. Erwin Panofsky, "The History of the Theory of Human Proportions as a Reflection of the History of Styles," in *Meaning in the Visual Arts* (New York: Doubleday, 1955), p. 89. The discussion here and below draws on Panofsky's essay.

3. Arnold Hauser, *The Social History of Art*. 4 vols. (New York: Vintage, 1957), vol. 1, p. 41.

4. Jared French, *Art International*, April 1968, p. 54.

5. C. G. Jung, *The Archetypes and the Collective Unconscious*, Bollingen Series, vol. 20 (Princeton: Princeton University Press, 1969), p. 121.

6. Ibid., p. 131.

7. See ibid., p. 17. "[T]he way of the soul in search of its lost father—like Sophia seeking Bythos—leads to the water, to the dark mirror that reposes at its bottom.... This water is no figure of speech, but a living symbol of the dark psyche."

8. For a discussion of the kouros and French's work, see Jeffrey Wechsler, *Realism and Realities: The Other Side of American Painting, 1940–1960* (New Brunswick, N.J.: Rutgers University, 1981), pp. 96–97.

9. Jung, *Archetypes*, p. 29.

10. Ernst Cassirer, *The Philosophy of Symbolic Forms*. 2 vols. (New Haven: Yale University Press, 1955), vol. 2, *Mythical Thought*, p. 78.

11. Jung, *Archetypes*, p. 293. "The egg is a germ of life with a lofty symbolical significance. It is not just a cosmogonic symbol—it is also a 'philosophical' one. As the former it is the Orphic egg, the world's beginning; as the latter, the philosophical egg of the medieval natural philosophers, the vessel from which at the end of the *opus alchymicum* the homunculus emerges, that is, the Anthropos, the spiritual, inner and complete man, who in Chinese alchemy is called the *chen-jen* (literally, 'perfect man')."

12. Rackstraw Downes, *Art News*, February 1969, p. 14.

13. Gordon Brown, *Arts*, March 1969, p. 60.

14. James R. Mellow, *Art International*, March 1969, p. 36.

CHIMERA, c. 1960s
Pencil & ink on paper
39½ x 26 inches
Midtown Payson Galleries

1
SUMMER'S ENDING, 1939
Oil and tempera on canvas
24¼ x 40¼ inches
Collection of the Whitney Museum of American Art
Purchase, 39.24

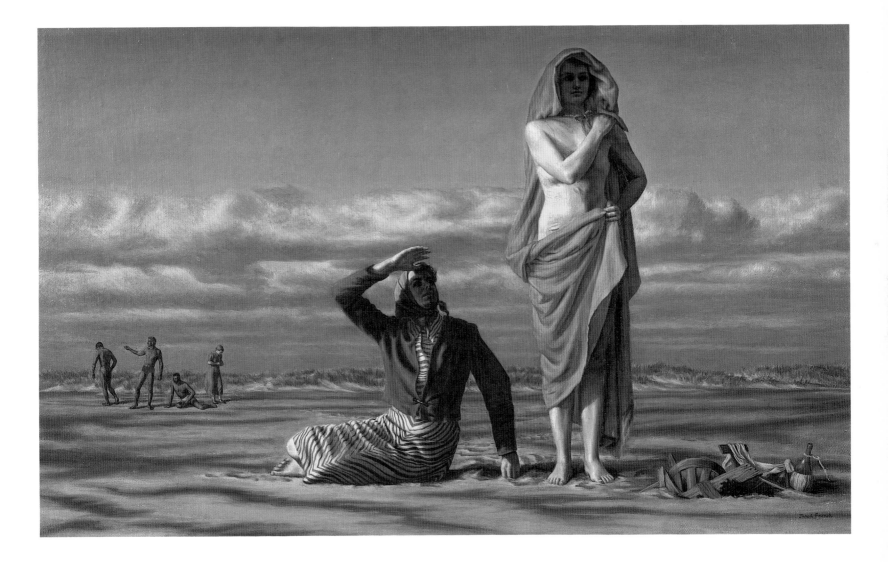

2
WASHING THE WHITE BLOOD FROM DANIEL BOONE, 1939
Egg tempera on gesso panel
29½ x 32 inches
William Kelly Simpson

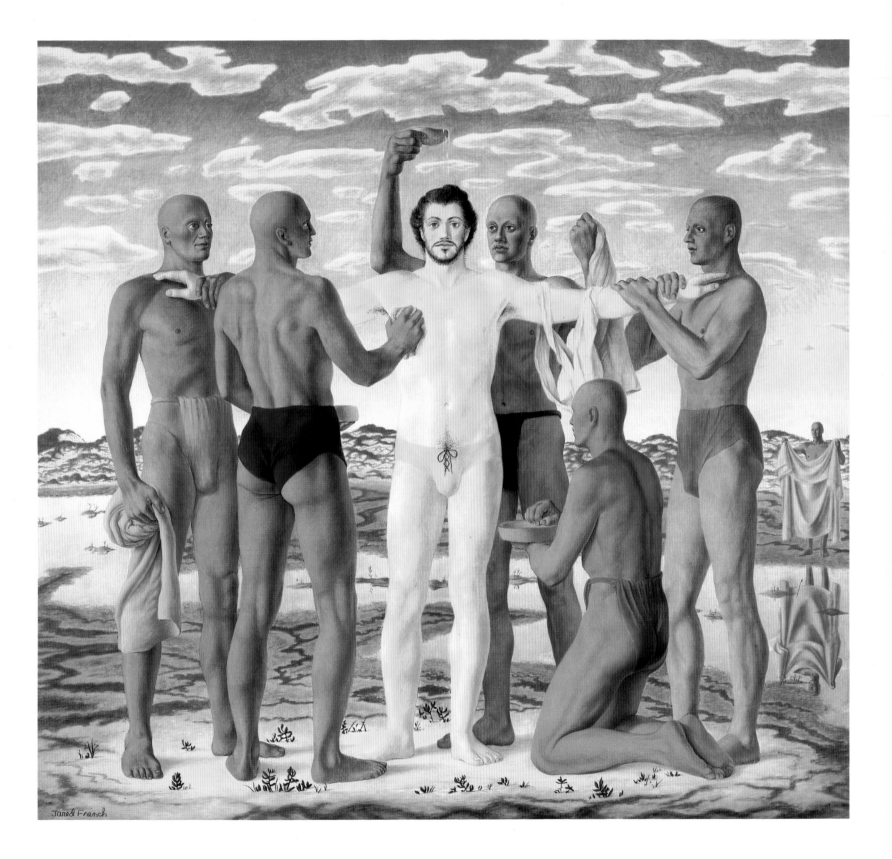

3
FIGURES ON A BEACH, 1940
Egg tempera on gesso on linen mounted on panel
21½ x 33⅜ inches
Private collection
Courtesy Midtown Payson Galleries

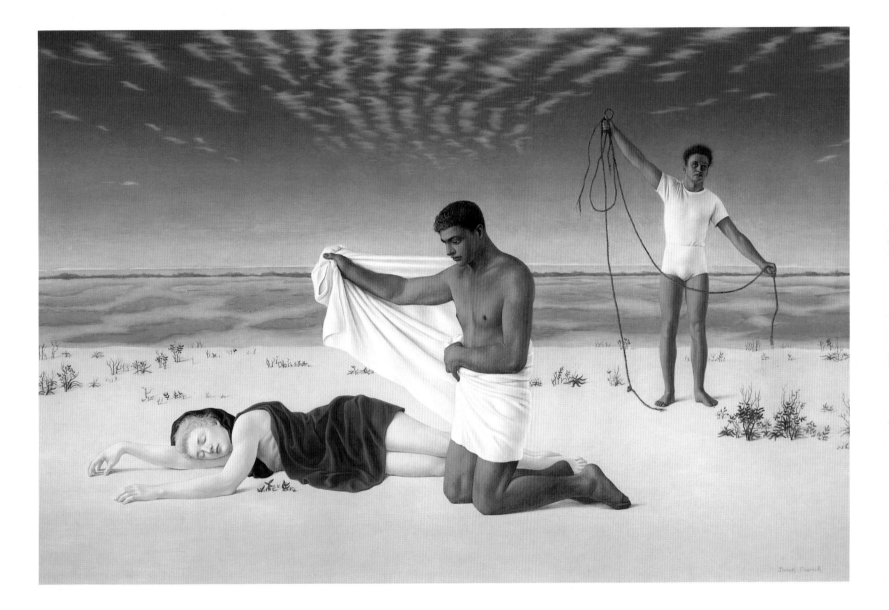

4
PORTRAIT OF MARGARET FRENCH, c. 1944
Egg tempera on gesso panel
5 x 6 inches
Private collection

5
WOMAN AND BOYS, 1944
Egg tempera on gesso on linen mounted to panel
32½ x 31⅝ inches
Private collection
Courtesy Midtown Payson Galleries

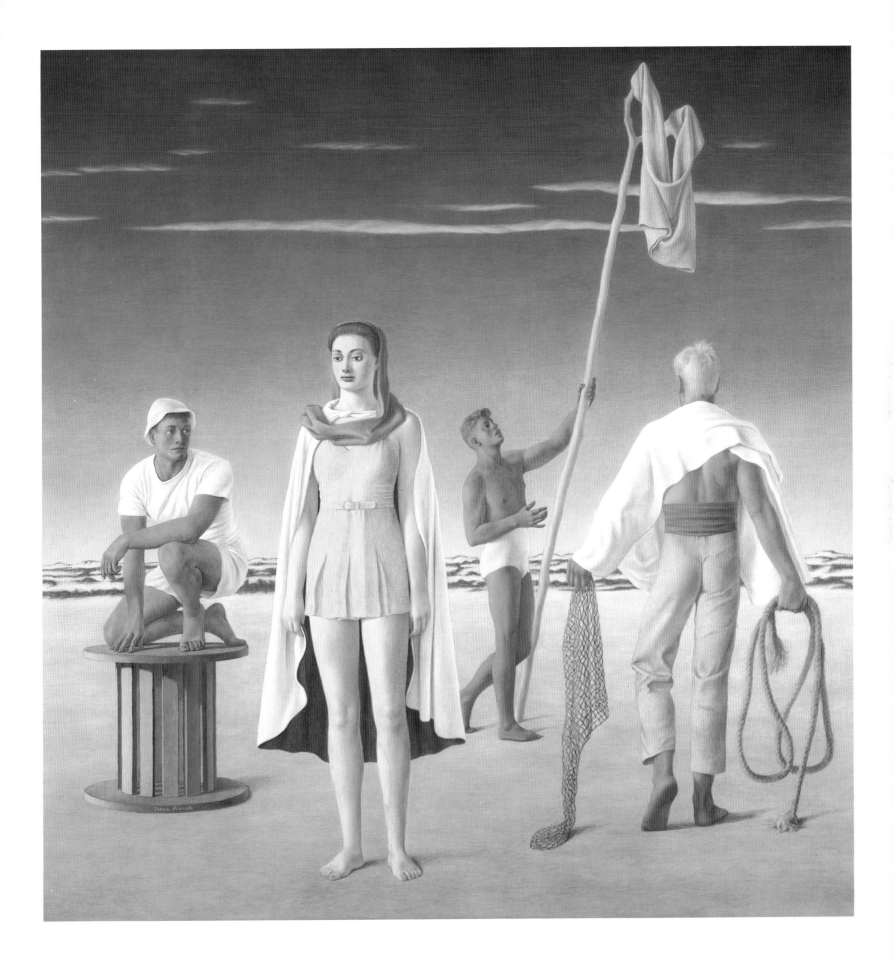

6
CREW, 1941–42
Egg tempera on gesso panel
9½ x 30½ inches
Midtown Payson Galleries

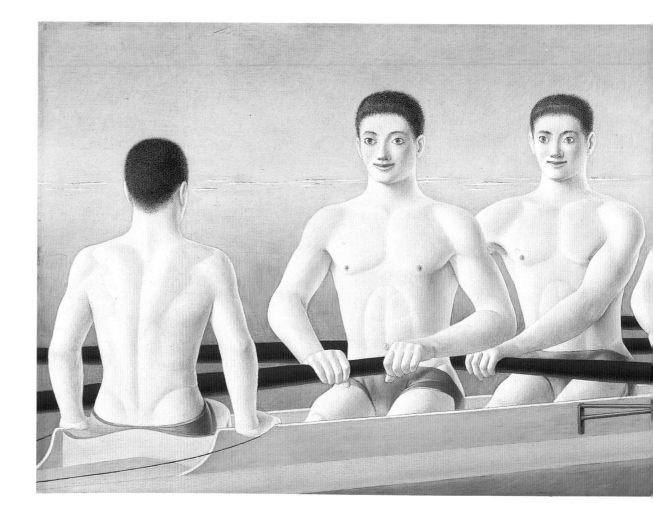

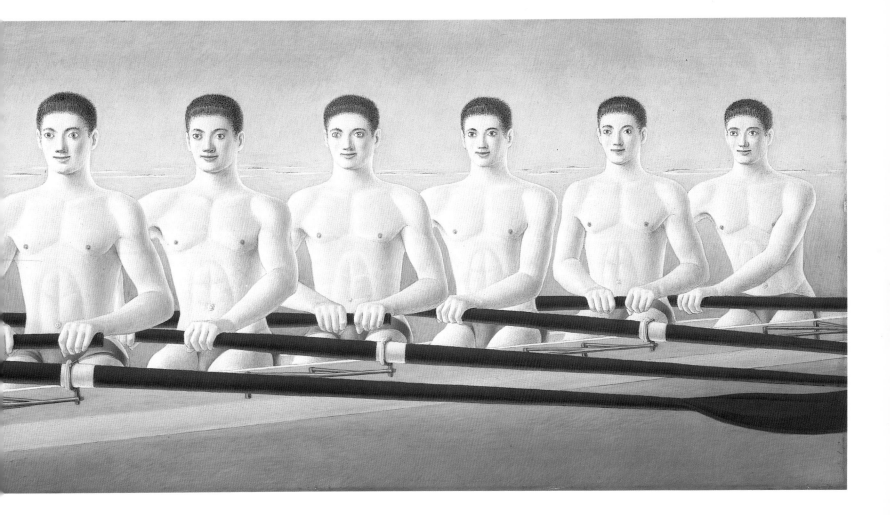

7
MURDER, 1942
Egg tempera on gesso panel
17 x 14½ inches
John P. Axelrod, Boston, MA

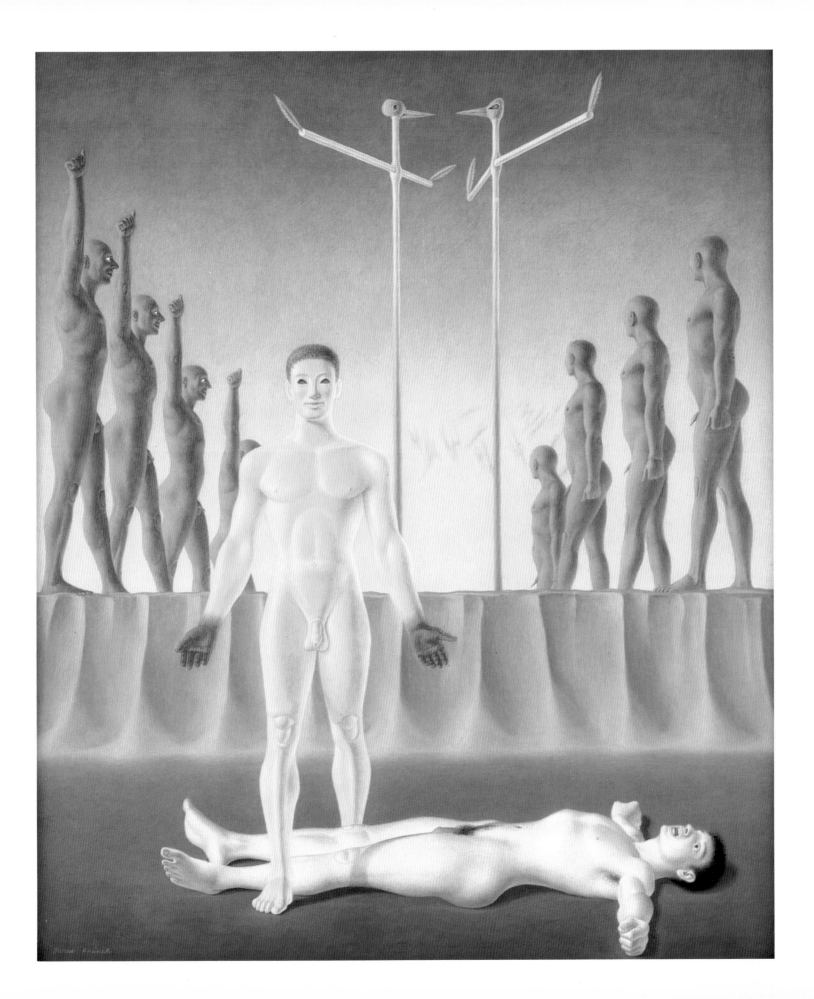

8
HOMESICKNESS, 1942
Egg tempera on gesso panel
11½ x 17½ inches
Donald Windham

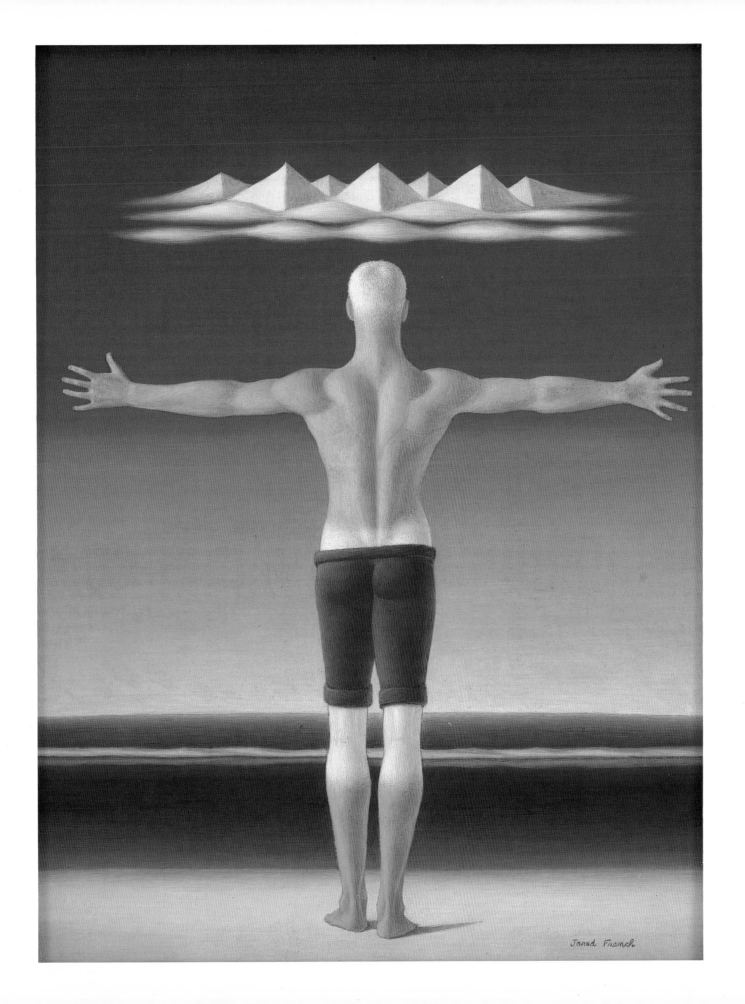

9
MUSIC, 1943
Egg tempera on gesso panel
11½ x 17½ inches
Donald Windham

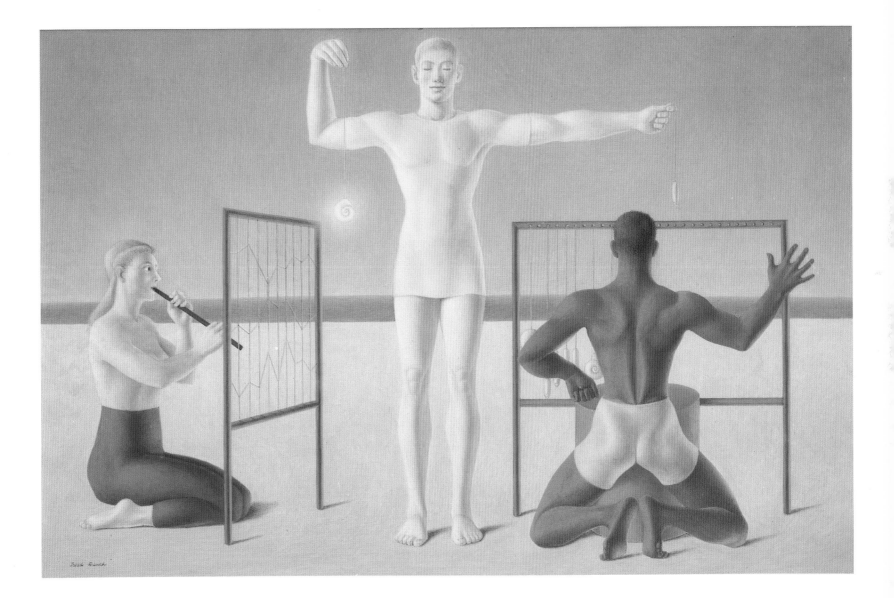

10
SHELTER, c. 1944
Egg tempera on gesso panel
16¾ x 16¾ inches
John P. Axelrod, Boston, MA

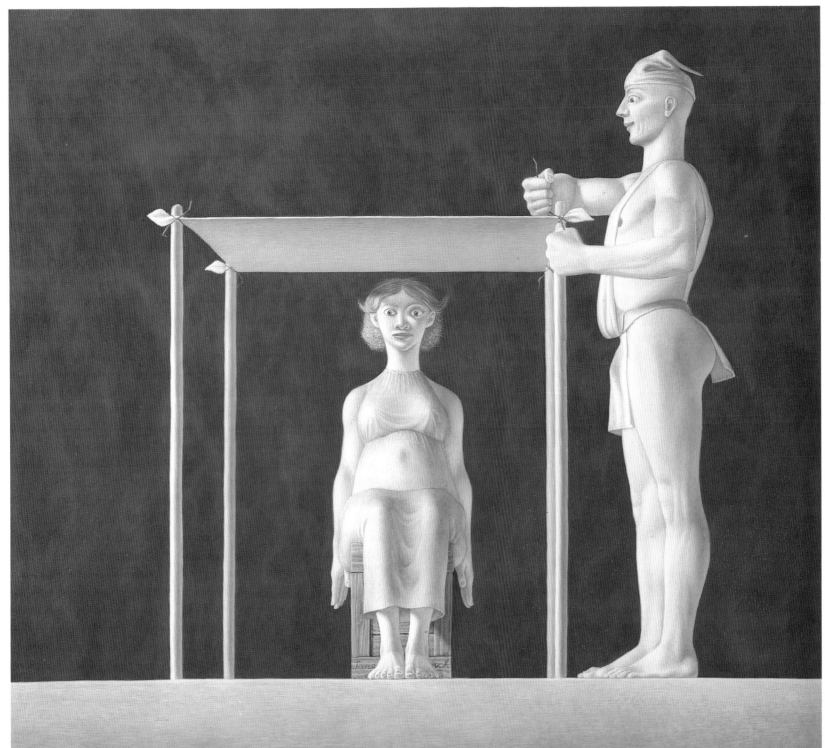

11
THE SEA, 1946
Egg tempera on gesso panel
26¾ x 37½ inches
Private collection

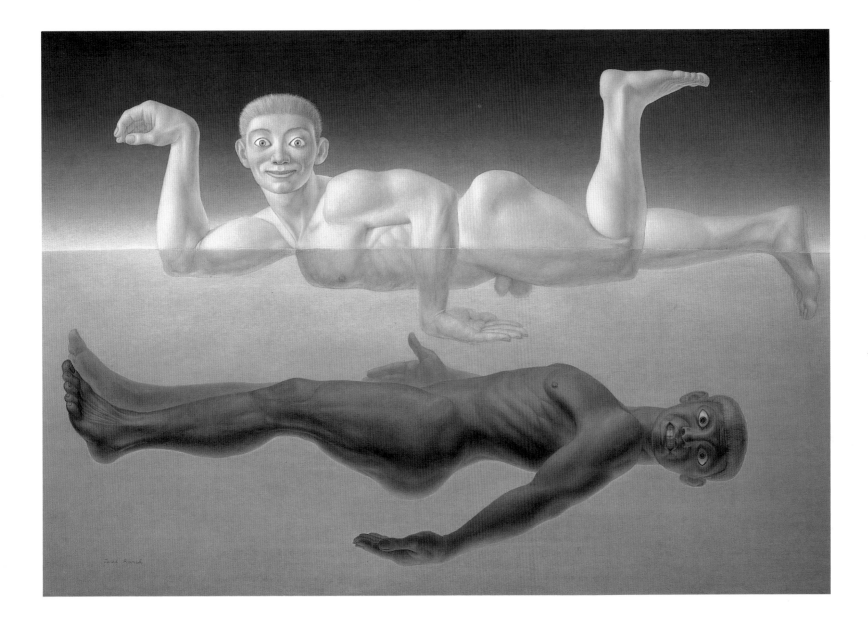

12
STATE PARK, 1946
Egg tempera on composition board
23½ x 23½ inches
Collection of the Whitney Museum of American Art
Gift of Mr. and Mrs. R.H. Donnelly Erdman, 65.78

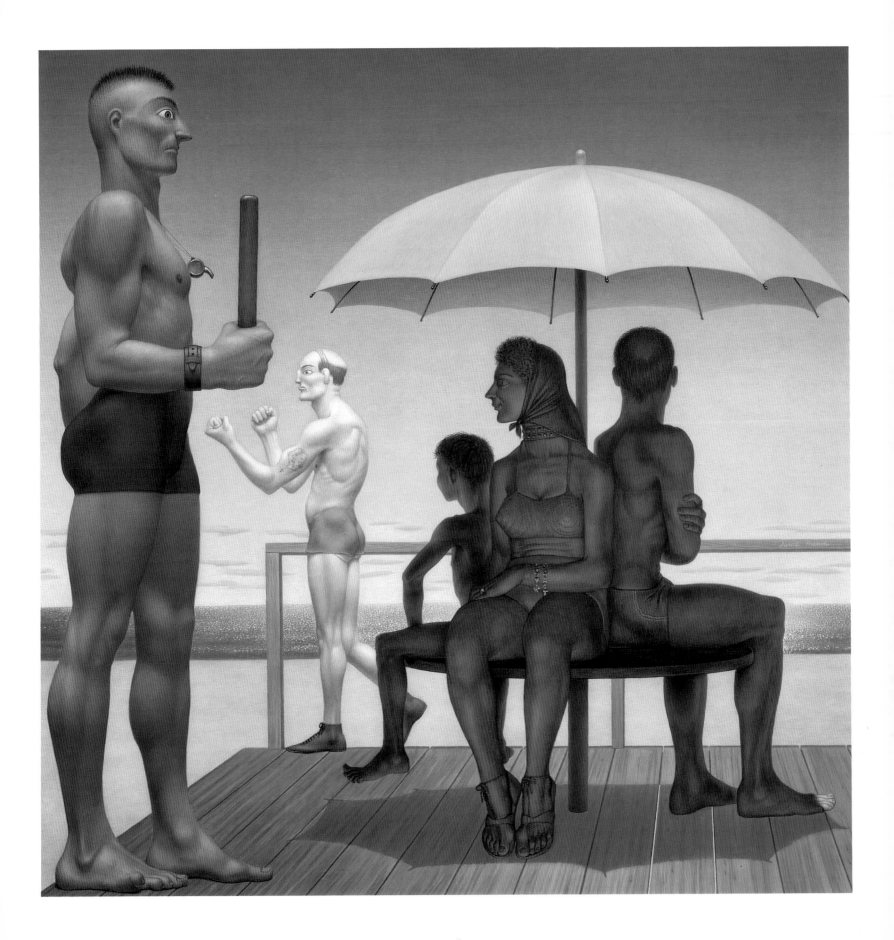

13
ELEMENTAL PLAY, 1946
Egg tempera on gesso panel
24½ x 36 inches
Private collection

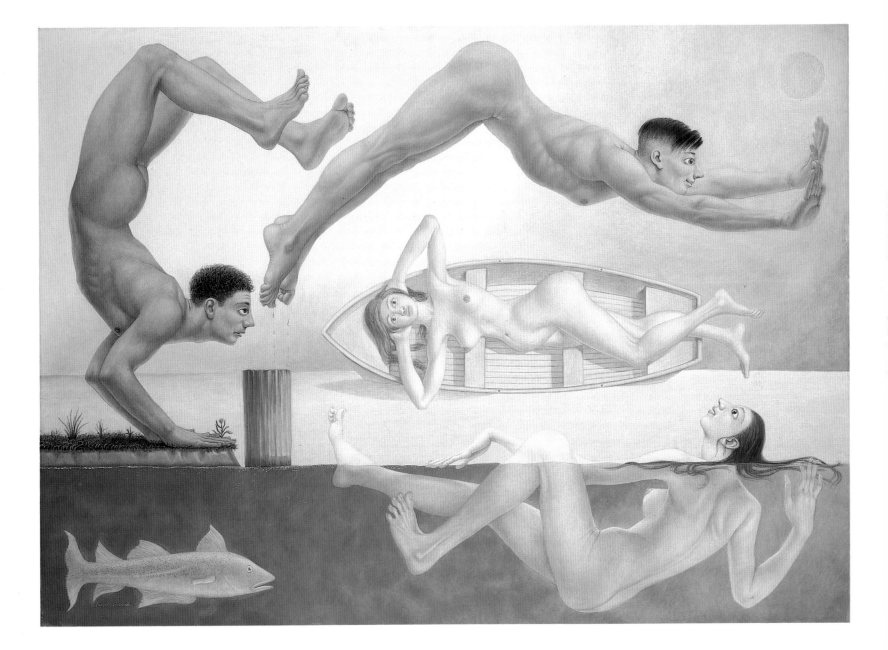

14
HELP, 1946
Egg tempera on ivory
2¼ x 1¹⁄₁₆ inches
Private collection

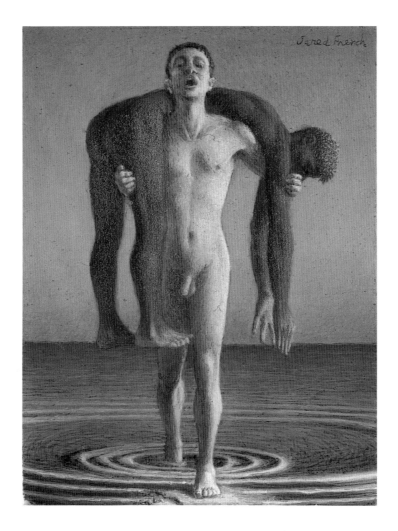

15
MUSCLES, 1944
Egg tempera on gesso panel
48 x 40 inches
Private collection
Courtesy Midtown Payson Galleries

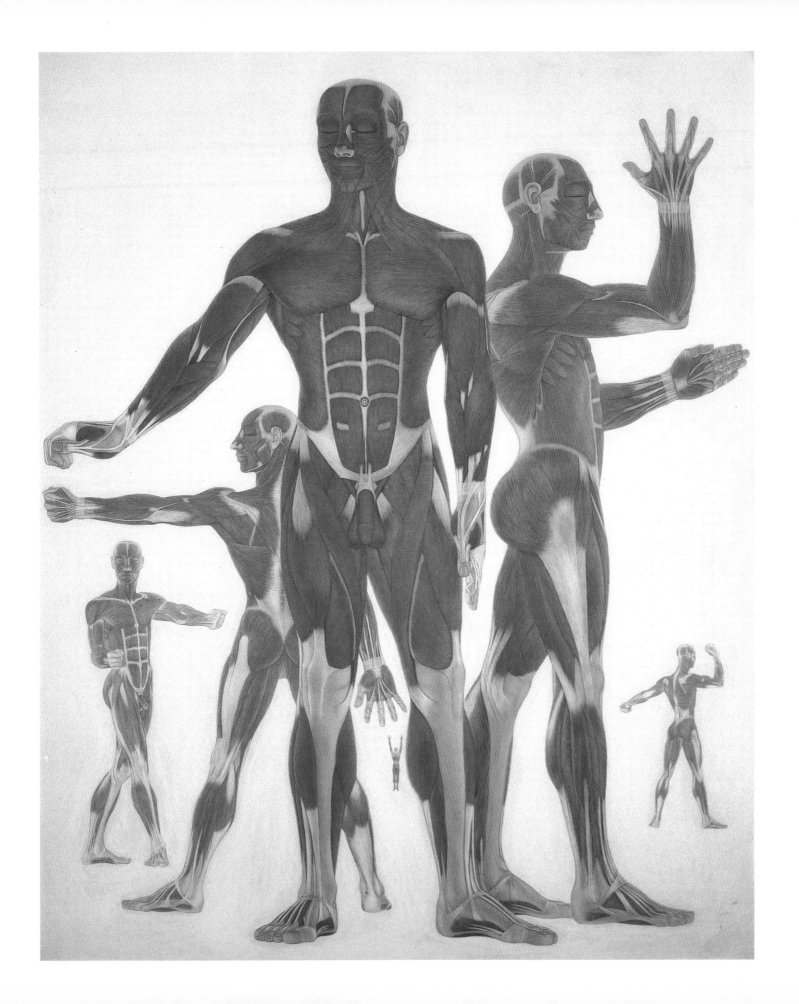

16
LEARNING, 1946
Egg tempera on gesso panel
24 x 22¾ inches
Private collection
Courtesy Midtown Payson Galleries

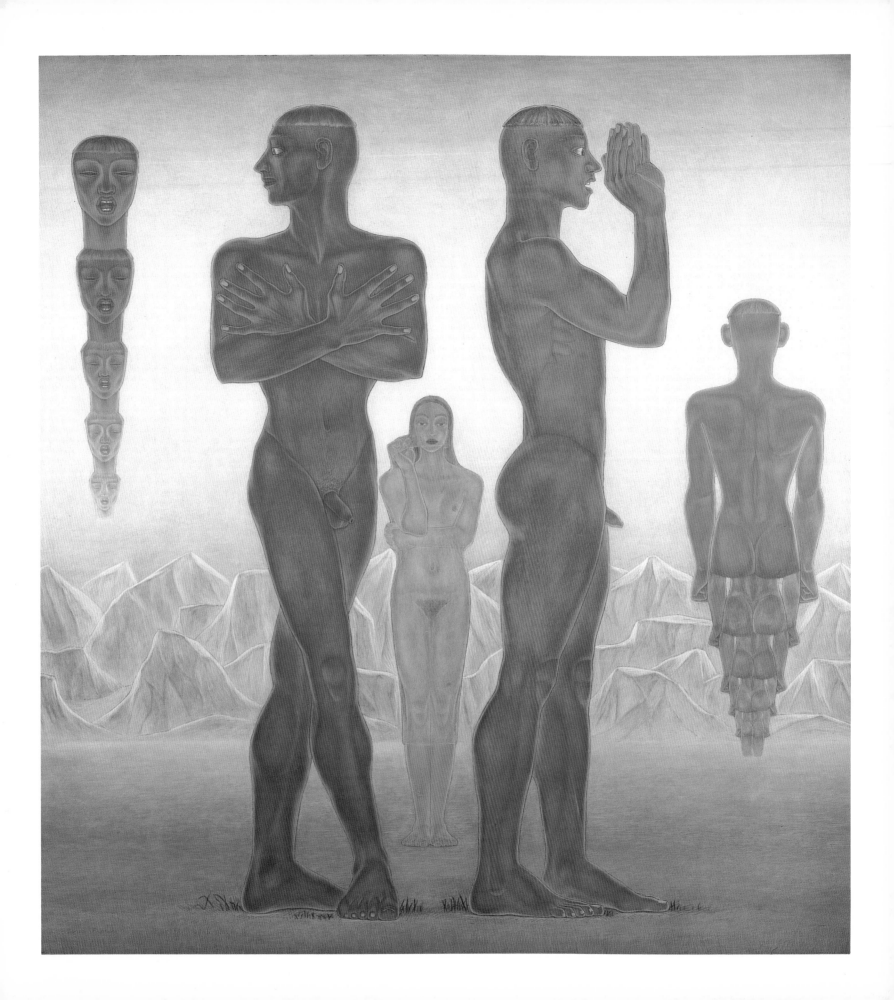

17
WOMAN, 1947
Egg tempera on gesso panel
17½ x 15 inches
Private collection
Courtesy Midtown Payson Galleries

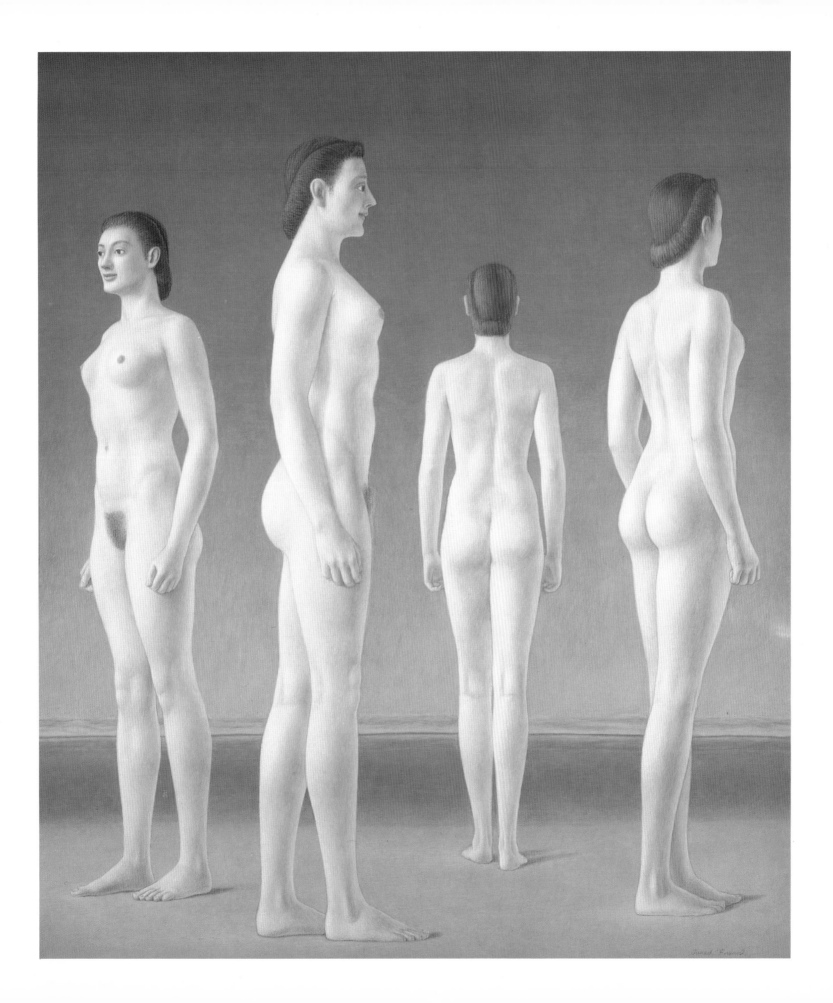

18
GLENWAY WESCOTT, c. 1940
Egg tempera on gesso on linen mounted to panel
16¼ x 7¼ inches
Private collection
Courtesy Midtown Payson Galleries

19
GEORGE PLATT LYNES, 1941–42
Egg tempera on gesso on linen mounted to panel
16½ x 7¼ inches
Private collection
Courtesy Midtown Payson Galleries

20
MONROE WHEELER, c. 1940
Egg tempera on gesso on linen mounted to panel
16½ x 7¼ inches
Private collection
Courtesy Midtown Payson Galleries

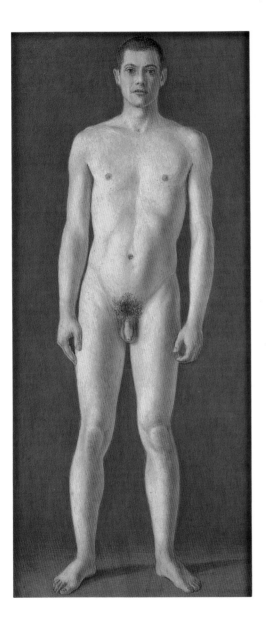
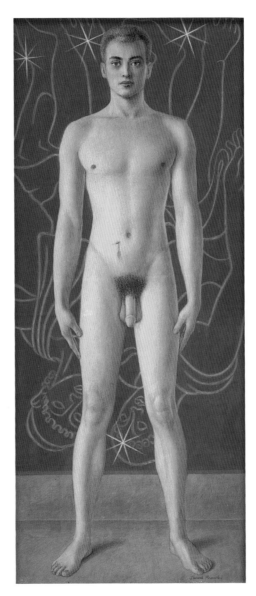
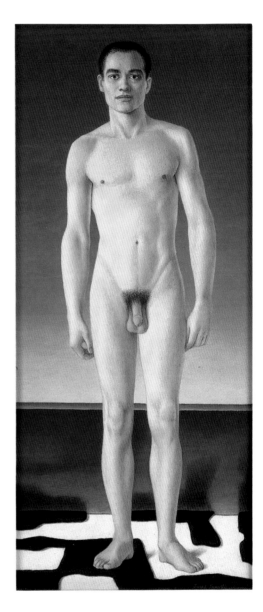

21
EVASION, 1947
Egg tempera on gesso panel
21½ x 11¼ inches
The Regis Collection, Inc.

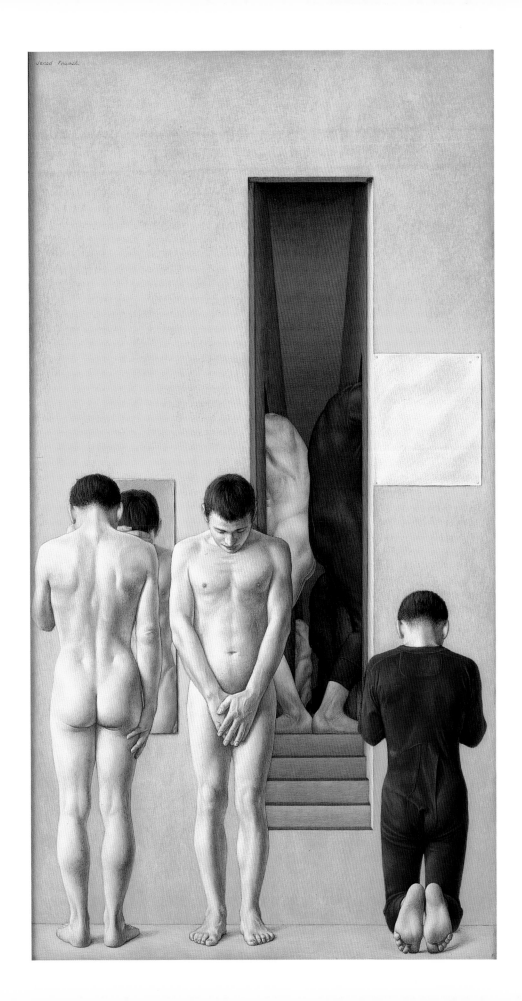

22
ARCHITECTURE, 1948
Egg tempera on gesso canvas mounted to panel
22 x 19 inches
Private collection

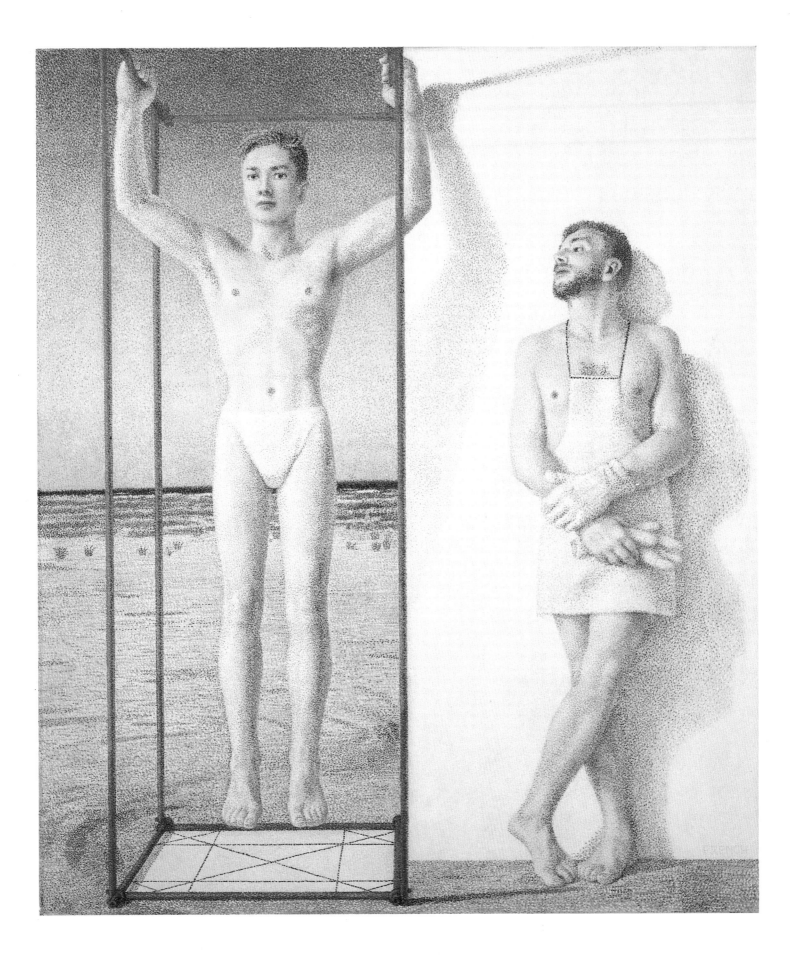

23
PAINTING AND SCULPTURE, c. 1949
Egg tempera on gesso panel
21 x 11¼ inches
Midtown Payson Galleries

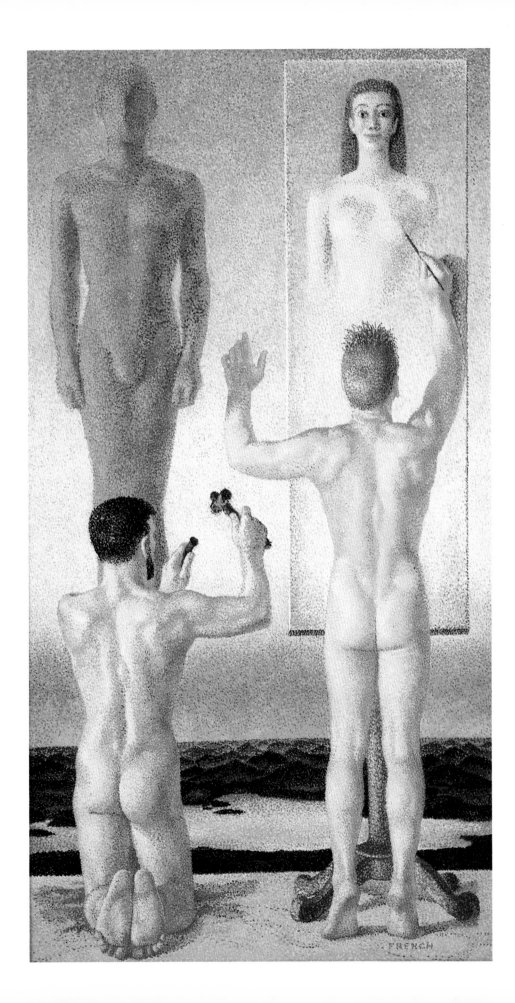

24
PROSE, c. 1948
Casein on panel
19 x 13¼ inches
John P. Axelrod, Boston, MA
Courtesy Midtown Payson Galleries

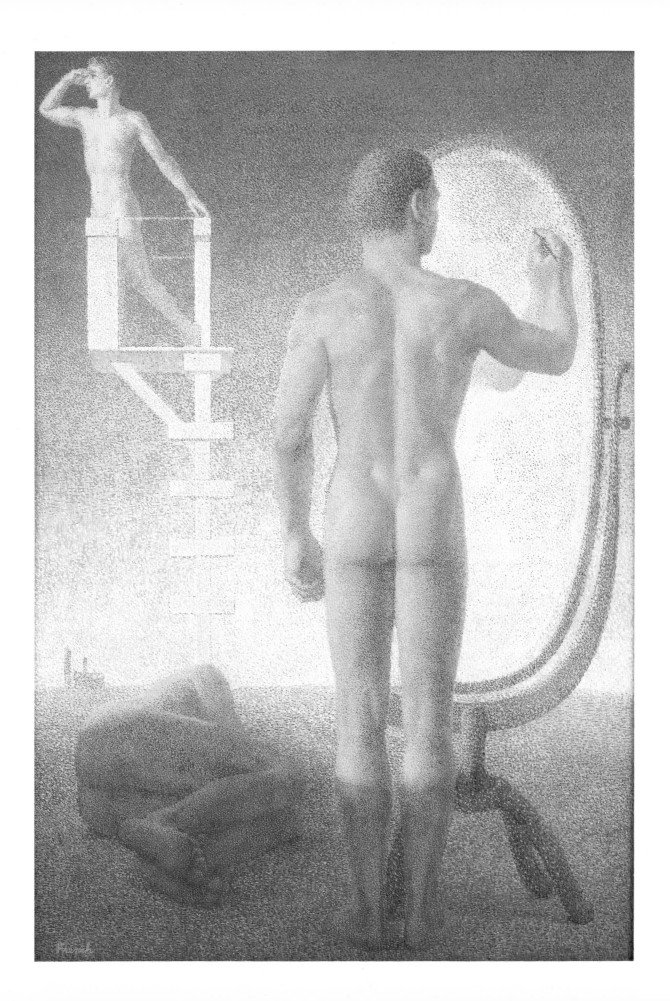

25
POETRY, n. d.
Egg tempera on gesso canvas mounted to panel
22 x 19 inches
Private collection

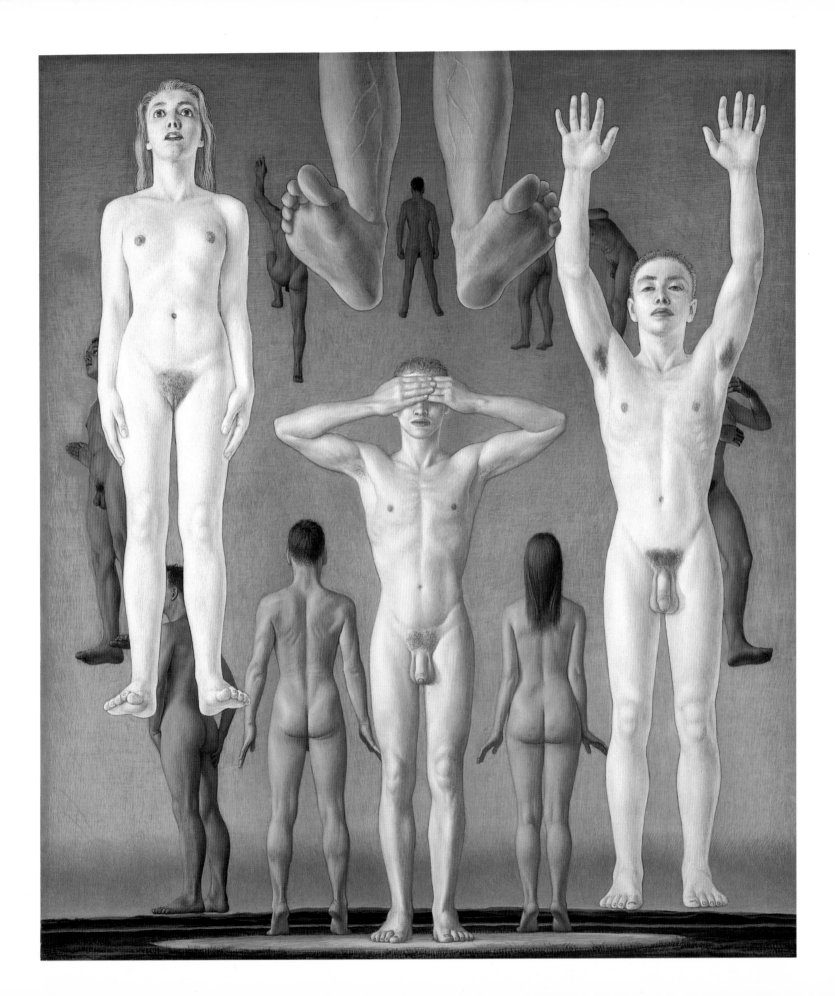

26
THE DOUBLE, c. 1950
Egg tempera on gesso panel
21¾ x 30 inches
Private collection
Courtesy Midtown Payson Galleries

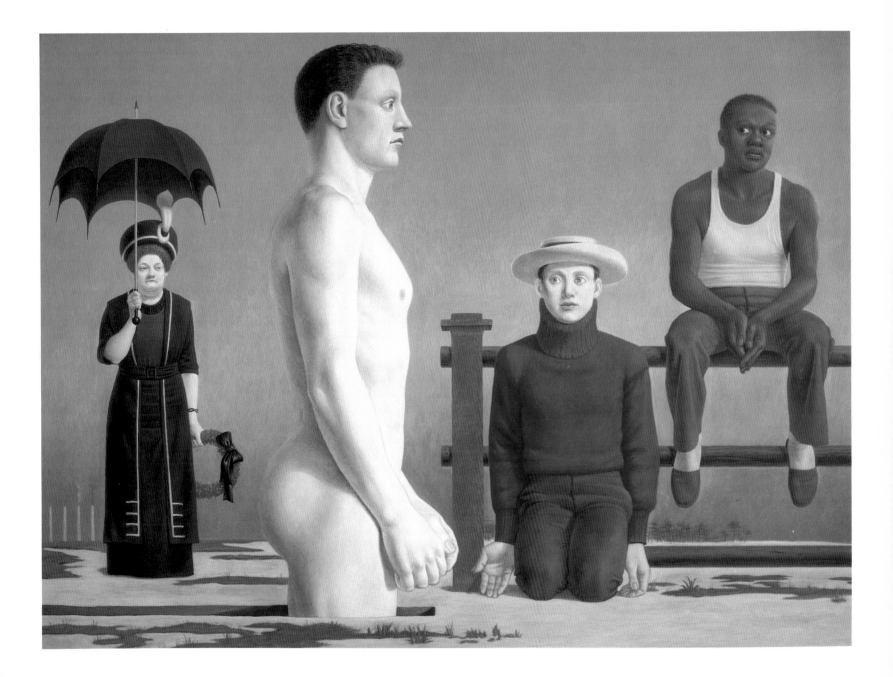

27
THE DOUBLE, 1950–62
Egg tempera on gesso panel
22 x 13 inches
Midtown Payson Galleries

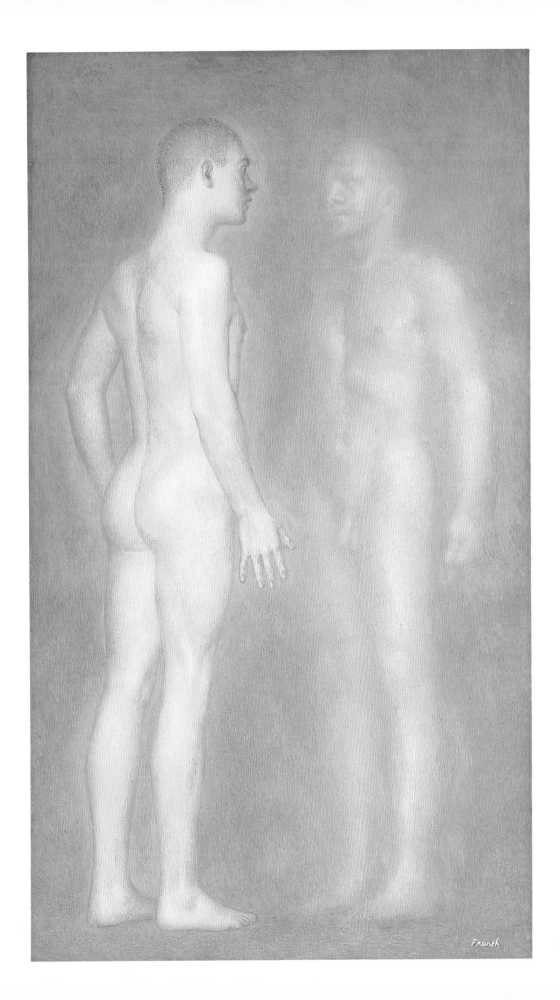

28
COUP DE PIED, 1953–59
Egg tempera on paper
22 x 31¼ inches
Norbert Sinski and George Dudley

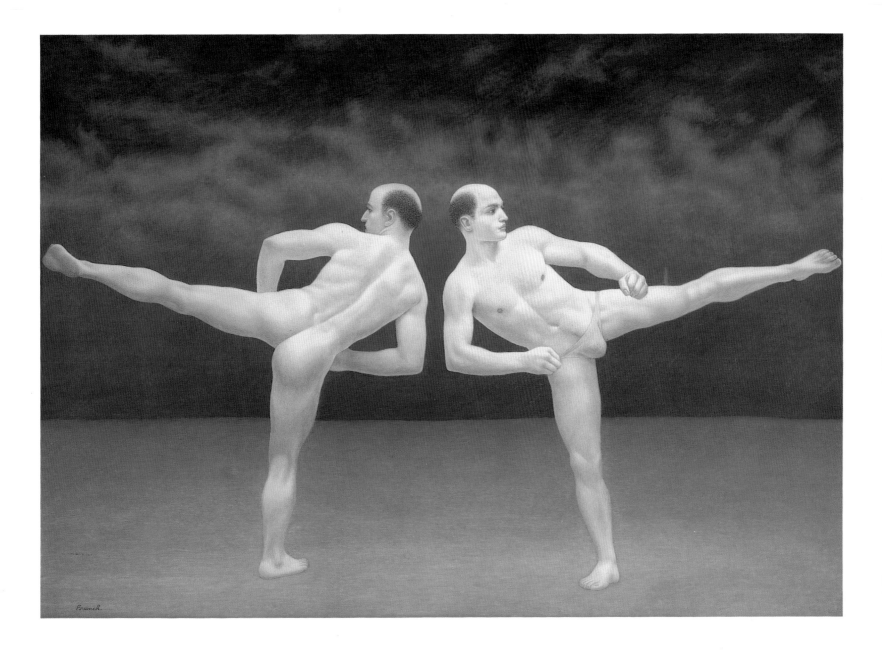

29
THE ROPE, 1954
Egg tempera on gesso panel
13½ x 14¼ inches
Collection of the Whitney Museum of American Art
Purchase, with funds from the
Charles F. Williams Fund 56.3

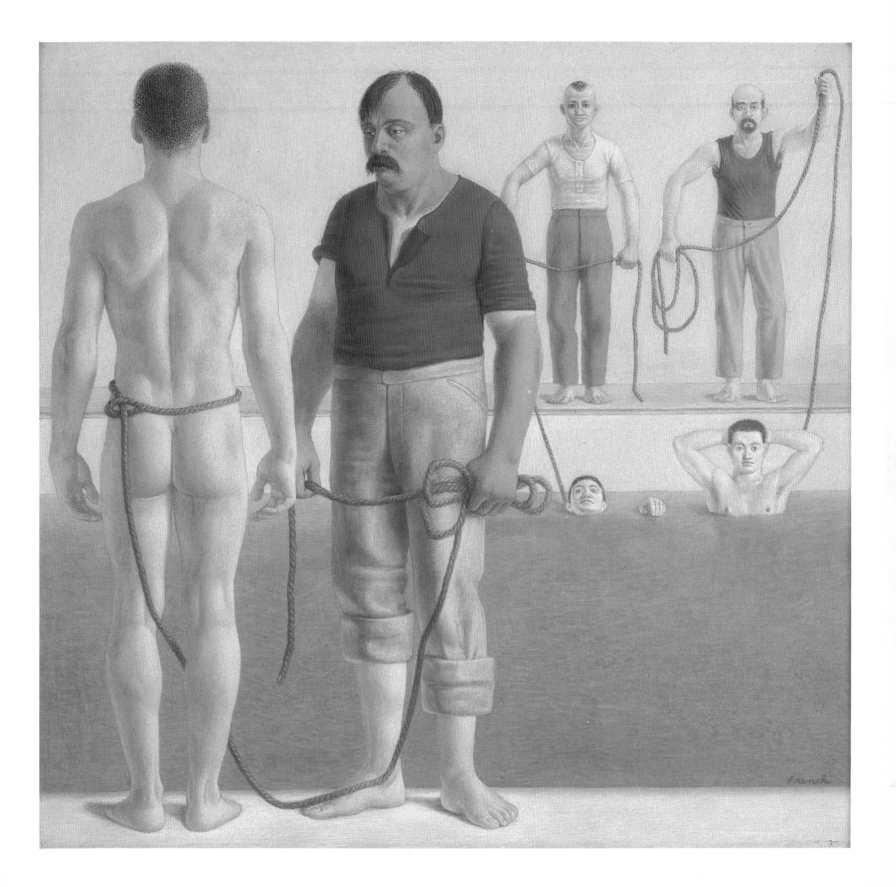

30
BUSINESS, 1959–61
Egg tempera on gesso panel
30 x 43 inches
The collection of Philip J. and Suzanne Schiller
American Social Commentary Art 1930–1970
Highland Park, Illinois

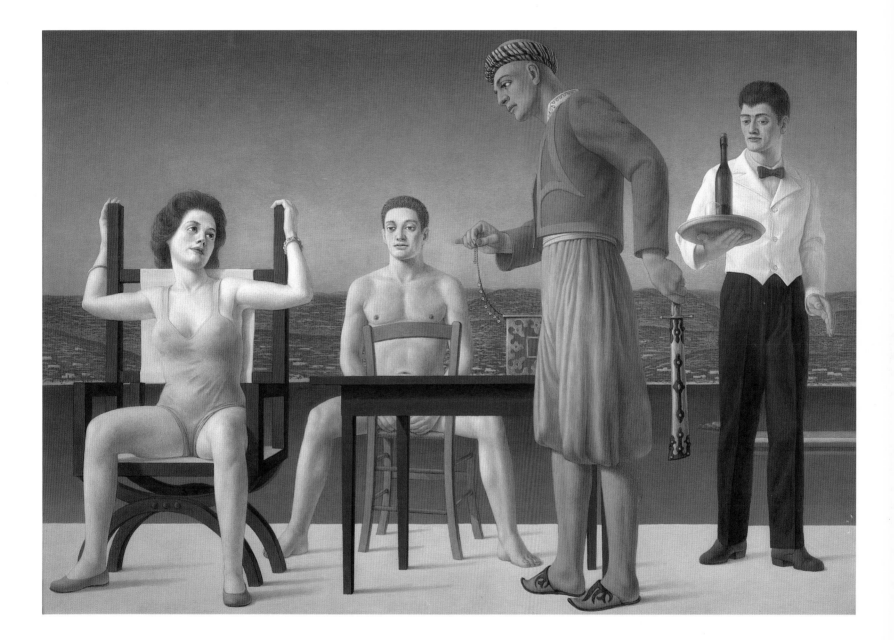

31
THAT FRENCH ISLAND, 1962–64
Egg tempera on gesso linen mounted to panel
30¾ x 15½ inches
Private collection

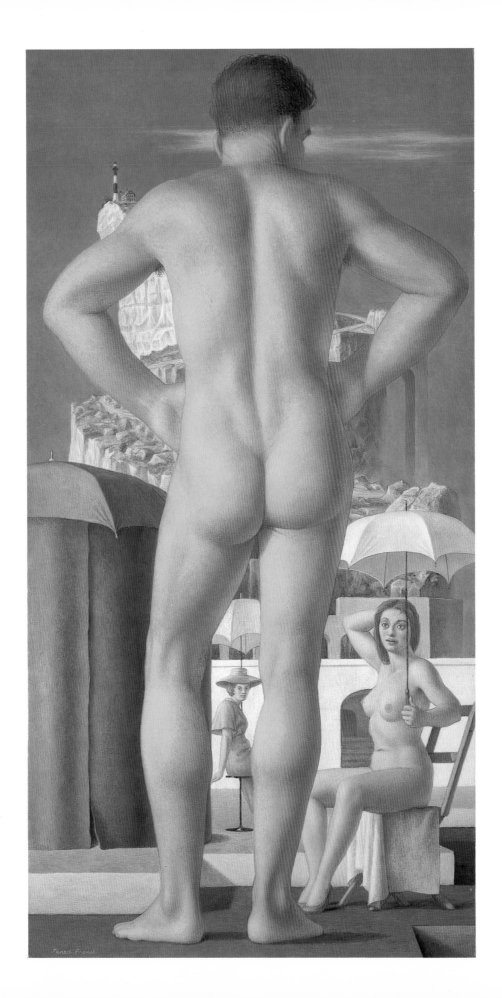

32
INTRODUCTION, c. 1944
Egg tempera on gesso panel
15 x 15 inches
Midtown Payson Galleries

33
NEST, 1968–69
Egg tempera on gesso panel
26¾ x 39 inches
Private collection

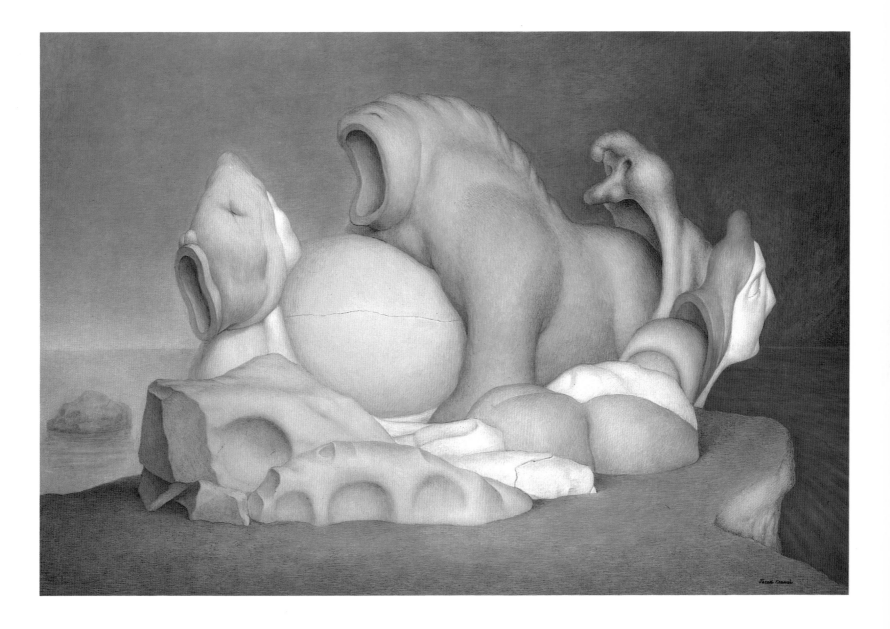

34
ANIMUS ANIMA, 1968–69
Egg tempera on gesso panel
23½ x 36 inches
Private collection

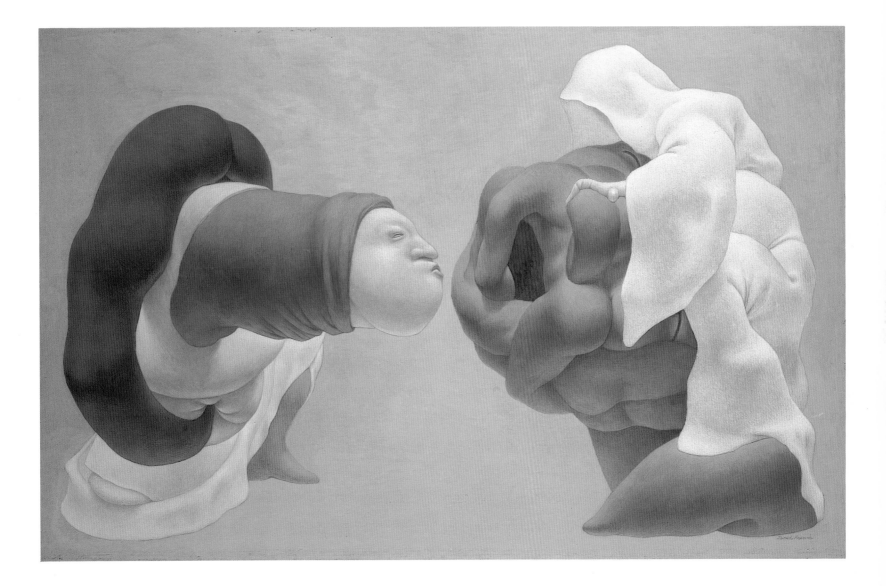

CHRONOLOGY AND EXHIBITION HISTORY

by Mark Cole

1905

Jared Blandford French, the second of three children, is born on February 4 in Ossining, New York to Henry Redfield French (1870-1962) and Mary Richards Blandford French (1870–1958). Shortly after his birth, the family relocates to Bradley Beach, New Jersey. His mother, a relatively accomplished amateur painter, initially encourages her son's interest in the visual arts. He later recalls, "I can't remember when I haven't drawn and painted."

1916

Enters Asbury Park High School, New Jersey.

ca. 1919

His family moves to Rutherford, New Jersey and he enrolls at Rutherford High School. His father creates a studio space for him above the garage of the new family home.

1920

Becomes stricken with appendicitis and nearly dies.

1921

Graduates from Rutherford High School with honors. Enters Amherst College in Massachusetts.

1925

Earns a Bachelor of Arts degree from Amherst College. Continues living with his family in Rutherford, New Jersey. While working as a clerk for a stockbroker on Wall Street, begins part-time study in painting and drawing at the Art Students League under Kimon Nicolaïdes and Boardman Robinson. In later years credits Robinson as having the most crucial impact on his early artistic development.

1926

Enrolls in an etching class taught by Allen Lewis at the Art Students League. Meets fellow student Paul Cadmus. The two eventually become lovers and lifelong friends.

1927-1928

Tours Spain, France, and Italy with friends from Amherst College.

1929

Leaves his job on Wall Street after the stock market crash and decides to become a professional artist.

1931-1933

Tours France, Spain, Italy, Germany, and Austria, visiting numerous art museums. Studies key works by El Greco, Signorelli, Giovanni Bellini, Rubens, and Goya. At photography shops in Rome and Florence, purchases hundreds of reproductions of Old Master paintings, which provide inspiration and source material for his own work. Shares a studio with Paul Cadmus in Puerto de Andraitx, a Mallorcan fishing village. Upon return to the United States, resumes living with his family in Rutherford.

1933

Enters the Mural and Easel Painting Section of the Public Works of Art Project, created under the auspices of the New Deal. Works in the manner of American Scene painting.

1934

Rents a residence and studio with Paul Cadmus at 54 Morton Street, New York City. Is elected a member of the National Society of Mural Painters. Shows his work for the first time in a major exhibition. Meets artist Margaret Hoening.

Exhibition:
Corcoran Gallery of Art, Washington, D.C.; Museum of Modern Art, New York: "National Exhibition of Art by the Public Works of Art Project."

1935

Moves with Paul Cadmus to 5 St. Luke's Place in Greenwich Village. Receives a commission from the Treasury Department Section of Painting and Sculpture to paint a mural for the post office in Plymouth, Pennsylvania. Is placed on the Works Progress (later Projects) Administration / Federal Art Project (WPA / FAP) payroll.

Exhibitions:
Grand Central Art Galleries, New York: "Mural Painting in America: Contemporary and Retrospective."
Arthur U. Newton Galleries, New York: "An Art Commentary on Lynching."
National Academy of Design, New York: "110th Annual Exhibition."
Corcoran Gallery of Art, Washington, D.C.: "14th Biennial Exhibition of Contemporary American Oil Paintings."
Art Institute of Chicago; Dallas Museum of the Fine Arts: "3rd International Exhibition of Etching and Engraving."
Art Institute, Chicago: "46th Annual Exhibition of American Paintings and Sculpture."
Cleveland Museum of Art: "2nd International Competitive Print Exhibition."
Dallas Museum of the Fine Arts: "Exhibition of Paintings, Drawings, Prints, and Sculpture Related to Circus Life."
Newman Galleries, Philadelphia: "9th Annual Philadelphia Society of Etchers and Graphic Artists."
National Arts Club, New York: "20th Annual Exhibition for the Society of American Etchers."
Downtown Gallery, New York; Baltimore Museum of Art: "9th Annual American Print Makers."

1936

Publishes a critique of entries submitted in a decorative mural competition sponsored by the Beaux-Arts Institute of Design, New York.

Exhibitions:
Whitney Musuem of American Art, New York: "2nd Biennial Exhibition, Part One: Sculpture, Drawings, and Prints."
National Academy of Design, New York: "111th Annual Exhibition."
Whitney Museum of American Art, New York: "Summer Exhibition."
Art Institute of Chicago; Dallas Museum of the Fine Arts: "47th Annual Exhibition of American Paintings and Sculpture."
Art Institute of Chicago; Cleveland Museum of Art: "4th International Exhibition of Etching and Engraving."
Corcoran Gallery of Art, Washington, D.C.: "Treasury Department Art Projects: Painting and Sculpture for Federal Buildings."
Whitney Museum of American Art, New York: "3rd Biennial Exhibition of Contemporary American Painting."
National Arts Club, New York: "21st Annual Exhibition of the Society of American Etchers."
Midtown Galleries, New York: "American Print Makers: 10th Anniversary Annual Exhibition."

1937

Marries Margaret Hoening and sets up residence at 33 Washington Square, but continues to share the St. Luke's Place studio with Paul Cadmus. Forms an informal photographic collaboration with Cadmus and Margaret French that is later christened "PAJAMA," an acronym of PAul, JAred, and MArgaret. Meets Lincoln Kirstein, an important patron and promoter of his work.

Exhibitions:
East River Gallery, New York: "Current Exhibition of Rental Pictures."
Grand Central Art Galleries, New York: "100 Prints."
National Academy of Design, New York: "112th Annual Exhibition."
Galerie Marcel Guiot, Paris: "Exposition de gravures."
Whitney Museum of American Art, New York: "Annual Exhibition of Contemporary American Painting."

1937-1945
Rents a summer cottage in Saltaire, Fire Island, with Margaret French and Paul Cadmus, where they establish summer studios.

1938
Designs the set and costumes for "Billy the Kid," a production of the Ballet Caravan, the touring company of the American Ballet, later the New York City Ballet.

Exhibitions:
Whitney Museum of American Art, New York: "Annual Exhibition of Contemporary American Sculpture, Watercolors, Drawings, and Prints."
Whitney Museum of American Art, New York: "Annual Exhibition of Contemporary American Painting."

1939
Completes two sets of murals for the WPA/FAP: a series of three panels for the Parcel Post Office in Richmond, Virginia, and seven panels for the New York State Vocational Institution, West Coxsackie, New York. Holds his first one-artist exhibition. Learns the technique of egg yolk tempera painting and creates his first work in this subsequently preferred medium.

Exhibitions:
Julien Levy Gallery, New York: "Murals by Jared French."
Whitney Museum of American Art, New York: "Annual Exhibition of Contemporary Sculpture, Drawings, and Prints."
Pennsylvania Academy of the Fine Arts, Philadelphia: "134th Annual Exhibition."
Vassar College Art Gallery, Poughkeepsie, New York; Morgan Hall, Amherst College, Massachusetts: "A Mural by Jared French."
Golden Gate International, San Francisco: "Fine Arts Exhibition."
World's Fair, Flushing Meadows, Queens, New York: "Exhibition of Contemporary American Art."
Whitney Museum of American Art, New York: "20th Century Artists."
Corcoran Gallery of Art, Washington, D.C.: "Exhibition of Painting and Sculpture Designed for Federal Buildings."

1940
Initiates work that is more consciously symbolic in its orientation, with a shift in imagery away from the American Scene.

Exhibitions:
Whitney Museum of American Art, New York: "Annual Exhibition of Contemporary American Painting."
Julien Levy Gallery, New York: "A Decade of Painting 1929-1939."
National Academy of Design, New York: "114th Annual Exhibition."
Whitney Museum of American Art, New York: "Annual Exhibition of Contemporary American Painting."

1941
Receives a commission from the Office for Emergency Management, a newly formed wartime federal bureau, to depict nonrestricted defense and war activities.

Exhibitions:
Whitney Museum of American Art, New York: "Annual Exhibition of American Sculpture, Watercolors, Drawings, and Prints."
Whitney Museum of American Art, New York: "This is Our City."

Art Institute of Chicago: "52nd Annual Exhibition of American Paintings and Sculpture."
Whitney Museum of American Art, New York: "Annual Exhibition of Paintings by Artists Under Forty."

1942
Exhibitions:
Arts Club of Chicago: "Nine American Painters."
National Gallery of Art, Washington, D.C.; Art Institute of Chicago; University Gallery, University of Minnesota, Minneapolis: "Art in War."
Metropolitan Museum of Art, New York: "Artists for Victory."
Museum of Modern Art, New York: "20th Century Portraits."

1943
Exhibitions:
Pennsylvania Academy of the Fine Arts, Philadelphia: "138th Annual Exhibition."
Jones Library, Amherst, Massachusetts: "Thirty Prints by Contemporary American Artists."
Museum of Modern Art, New York; Art Gallery of Toronto, Ontario: "American Realists and Magic Realists."
Whitney Museum of American Art, New York: "Annual Exhibition of Contemporary American Art."

1944
Meets artist George Tooker.

Exhibitions:
Museum of Modern Art, New York: "Modern Drawings."
Whitney Museum of American Art, New York: "Annual Exhibition of Contemporary American Painting."

1945
Exhibition:
Whitney Museum of American Art, New York: "Annual Exhibition of Contemporary American Sculpture, Watercolors, and Drawings."

1946
Is commissioned by *Dance Index* magazine to execute a portrait of Martha Graham. Spends the summer with Margaret French, Paul Cadmus, and George Tooker at Siasconset, Nantucket Island.

Exhibitions:
Carnegie Institute, Pittsburgh: "Painting in the United States 1946."
Whitney Museum of American Art, New York: "Annual Exhibition of Contemporary American Painting."

1947-1948
Summers at the Hawthorne House, Provincetown, Massachusetts with Margaret French, Paul Cadmus, and George Tooker.

1947
Meets E. M. Forster, one of his most admired authors, on Forster's first visit to the United States.

Exhibitions:
Whitney Museum of American Art, New York: "Annual Exhibition of Contemporary American Sculpture, Watercolors, and Drawings."
Carnegie Institute, Pittsburgh: "Painting in the United States 1947."
California Palace Legion of Honor, San Francisco: "2nd Annual Exhibition."
Whitney Museum of American Art, New York: "Annual Exhibition of Contemporary American Painting."

1948
Exhibitions:
Whitney Museum of American Art, New York: "Annual Exhibition of Contemporary American Sculpture, Watercolors, and Drawings."
Carnegie Institute, Pittsburgh: "Painting in the United States, 1948."

Worcester Art Museum, Massachusetts: "Biennial Exhibition."
Whitney Museum of American Art, New York: "Annual Exhibition of
 Contemporary American Painting."

1949
Begins to exhibit work in a pointillist style. Moves to 5 St. Luke's Place with
Margaret French. Hosts E. M. Forster on the author's return visit to New
York. Publishes "The New Disorder," an essay written by Forster in 1941.
Starts an association with the Edwin Hewitt Gallery, New York, subsequently
incorporated as the Robert Isaacson Gallery. Later in the year tours Venice,
Paris, Florence, Rome, and London with Margaret French, Paul Cadmus,
and George Tooker.

Exhibitions:
Whitney Museum of American Art, New York: "Annual Exhibition of
Contemporary American Sculpture, Watercolors, and Drawings."
Whitney Museum of American Art, New York: "Juliana Force and American
 Art."
Carnegie Institute, Pittsburgh: "Painting in the United States, 1949."
Whitney Museum of American Art, New York: "Annual Exhibition of
 Contemporary American Painting."

1950-1953
Takes an extended trip to Europe with Margaret French and Paul Cadmus.
Travels through England, Denmark, Germany, Switzerland, Austria, Italy,
Sicily, France, Spain, and the Balearic Islands.

1950
Visits Copenhagen, Hamburg, Bonn, Freiburg, Lucerne, Venice, Menor-
ca, and Capri. Rents a villa during the winter months in Beaulieu-sur-mer
on the southeast coast of France.

Exhibitions:
Whitney Museum of American Art, New York: "Annual Exhibition of
 Contempoary American Sculpture, Watercolors, and Drawings."
Edwin Hewitt Gallery, New York: "Symbolic Realism."
Institute of Contemporary Art, London: "Symbolic Realism in American
 Painting, 1940-1950."
Edwin Hewitt Gallery, New York: "Jared French Drawings, 1925 – 1950."

1951
Visits Paris, London, Copenhagen, and Rome. Eventually settles in Florence
where he maintains a studio. Remains centered in Florence for the duration
of the overseas stay, but makes excursions to Salzburg, Venice, Bologna,
Rome, Vienna, and Concarneau, a French fishing village on the Bay of Biscay.

Exhibitions:
Edwin Hewitt Gallery, New York: "The New Reality."

1953
Exhibition:
Whitney Museum of American Art, New York: "Annual Exhibition of
 Contemporary American Painting."

1954
Exhibitions:
Whitney Museum of American Art, New York: "Annual Exhibition of
 Contemporary American Sculpture, Watercolors, and Drawings."
Walker Art Center, Minneapolis: "Reality and Fantasy, 1900-1954."
Edwin Hewitt Gallery, New York: "Magic Realists."

1955
Exhibitions:
Whitney Museum of American Art, New York: "Annual Exhibition of
 Contemporary American Sculpture, Watercolors, and Drawings."
University Galleries, University of Nebraska, Lincoln; Joslyn Art Museum,
 Omaha: "Nebraska Art Association 65th Annual Exhibition of
 Contemporary American Painting."

Edwin Hewitt Gallery, New York: "Paintings and Drawings by Jared
 French."
Edwin Hewitt Gallery, New York: "Sharp-focus Realism."
Whitney Museum of American Art, New York: "Annual Exhibition of
 Contemporary American Painting."

1956
Purchases a farm in Hartland, Vermont, living there for portions of the year
during the next decade and a half.

Exhibitions:
Whitney Museum of American Art, New York: "Annual Exhibition of
 Contemporary American Sculpture, Watercolors, and Drawings."

1957
Begins exhibiting sculpture.
Exhibitions:
Edwin Hewitt Gallery, New York: "Contemporary American Realism."
Whitney Museum of American Art, New York: "Annual Exhibition:
 Sculpture, Paintings, Watercolors."

1958
Exhibition:
Edwin Hewitt Gallery, New York: "Twelve Galleries of American Painting."

1959
Exhibition:
Whitney Museum of American Art, New York: "Annual Exhibition of
 Contemporary American Painting."

1961
Begins maintaining a residence in Rome, and eventually relocates there
permanently.

Exhibition:
Whitney Museum of American Art, New York: "Annual Exhibition of
 Contemporary American Painting."

1962
Exhibitions:
Robert Isaacson Gallery, New York: "Group Show: Browning, Connely,
 French, Mayhew, Ross, Schmidt."
Robert Isaacson Gallery, New York: "Jared French: Paintings and Drawings."
Currier Gallery of Art, Manchester, New Hampshire: "100 American
 Drawings from the Collection of Paul Magriel."
Whitney Museum of American Art, New York: "Annual Exhibition:
 Contemporary Sculpture and Drawings."

1963
Is represented by the Banfer Gallery in New York.

Exhibitions:
Banfer Gallery, New York: "Painting and Drawing the Nude, Part I: The
 Male."
Whitney Museum of American Art, New York: "Annual Exhibition:
 Contemporary American Painting."
Banfer Gallery, New York: "Painting and Drawing the Nude, Part II:
 The Female."

1964
Abandons working in a figurative mode and begins a series of large-scale
drawings in a nonrepresentational style.

Exhibitions:
Banfer Gallery, New York: "World's Fair Group Show."
University of Texas Art Museum, Austin: "Paul Magriel Collection."
Whitney Museum of American Art, New York: "Art Between the Fairs: 25
 Years of American Art, 1939-1964."
Banfer Gallery, New York: "The Magic of Realism."

Memorial Art Gallery, University of Rochester, New York: "In Focus: A Look at Realism in Art."

1965
Exhibition:
Banfer Gallery, New York: "Jared French."

1966
Exhibition:
Whitney Museum of American Art, New York: "Art of the United States, 1670-1966."

1967
Receives an honorary grant of $2,500 from the American Academy and National Institute of Arts and Letters in New York.

Exhibitions:
Academy Art Gallery, National Institute of Arts and Letters, New York: "An Exhibition of Contemporary Painting, Sculpture, and Graphic Art."
Academy Art Gallery, National Institute of Arts and Letters, New York: "Exhibition of Work by Newly Elected Members and Recipients of Honors and Awards."
Butler Institute of American Art, Youngstown, Ohio: "32nd Annual Midyear."
Banfer Gallery, New York: "Jared French: 20 New Works."
Banfer Gallery, New York: "Magic Realism."

1968
Issues a brief artist's statement, reprinted in the April issue of *Art International* magazine.

Exhibition:
Saint Paul Art Center, Minnesota: "Drawings USA '68."

1969
Holds his last one-artist exhibition.

Exhibitions:
Banfer Gallery, New York: "Realism '69."
Banfer Gallery, New York: "Jared French: 25 Years of Paintings and Drawings from 1944 to 1969."

1972
Exhibition:
New York Cultural Center, New York: "Collectors Anonymous: Four Private New York Collections."

1974
Continues to work despite troubled eyesight.

1975
Exhibition:
Whitney Museum of American Art, New York: "An American Dream World: Romantic Realism 1930-1955.

1977
Exhibition:
Rutgers University Art Gallery, New Brunswick, New Jersey: "Surrealism and American Art, 1931-1947."

1978
Exhibitions:
Print Cabinet, Ridgefield, Connecticut: "The Photography Collection of Paul Cadmus."
Montgomery Museum of Fine Arts, Alabama; Brooks Memorial Art Gallery, Memphis; Mississippi Museum of Art, Jackson: "American Art 1934-1956: Selections from the Whitney Museum of American Art."

1979
Exhibition:
Robert Samuel Gallery, New York: "Works on Paper."

1980
Exhibition:
Robert Samuel Gallery, New York: PAJAMA Photographs, 1937-1954."

1981
Exhibition:
Whitney Museum of American Art, New York: "A Decade of Transition 1940-1950."

1982
Exhibition:
Rutgers University Art Gallery, New Brunswick, New Jersey; Montgomery Museum of Fine Arts, Alabama; Art Gallery, University of Maryland, College Park: "Realism and Realities: The Other Side of American Painting 1940-1960."

1987
Exhibition:
Midtown Galleries, New York: "Group Exhibition."

1988
Dies in Rome on January 15.

Exhibitions:
National Museum of American Art, Smithsonian Institution, Washington, D.C.; Museum of Fine Arts of St. Petersburg, Florida; Picker Art Gallery, Colgate University, Hamilton, New York; Davenport Museum of Art, Iowa; Montgomery Museum of Fine Arts, Alabama; Georgia Museum of Art, Athens; Samuel P. Harn Museum of Art, Gainesville, Florida: "Special Delivery: Murals for the New Deal Era."
Midtown Galleries, New York: "The Nude: Past and Contemporary Views."

1989
Exhibition:
Weatherspoon Art Gallery, Greensboro, North Carolina: "Art on Paper."

1990
Exhibitions:
Midtown Galleries, New York: "The Reflective Image: American Drawings 1910 – 1960."
Midtown Galleries, New York: "Close Encounters: The Art of Paul Cadmus, Jared French, George Tooker."
Whitney Museum of American Art at Philip Morris, New York: "Cadmus, French, and Tooker: The Early Years."
Midtown Payson Galleries, New York: "An Artist's Christmas: Holiday Images by American Artists 1880-1990."

1991
Exhibitions:
Twining Gallery, New York: "The Nude: Drawings of the Figure by New York School Artists 1930-1955."
Whitney Museum of American Art, New York: "American Life in American Art 1900-1950."
Midtown Payson Galleries, New York: "American Drawings, American Prints."

1992
Exhibitions:
Hood Museum of Art, Dartmouth College, Hanover, New Hampshire: "Picturing New York: Images of the City, 1890-1955."
Midtown Payson Galleries, New York; Mead Museum of Art, Amherst College, Massachusetts: "The Rediscovery of Jared French."

1993
Exhibition:
Midtown Payson Galleries, New York: "The Artist as Subject: Paul Cadmus."